IMAGES
of America

THE STATE OF
JEFFERSON

Gail L. Jenner

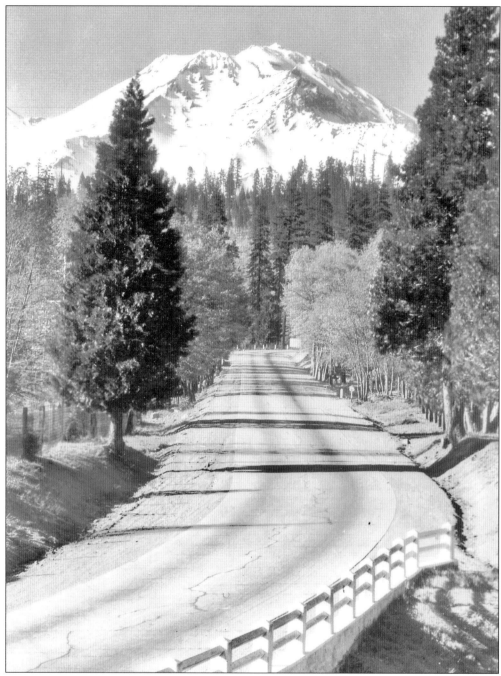

Mount Shasta is part of the Cascade Mountain Range, reaching 14,162 feet in elevation. Shasta's last known eruption was noted in 1786 in the logs of sea captains on the Pacific Ocean. This c. 1950 photograph was taken from old Highway 99, looking north. Mount Shasta has long been considered the "Jewel of Siskiyou County." (Courtesy Nolan Printing.)

ON THE COVER: A Fourth of July celebration parades down Main Street in Etna, California, just after the turn of the 20th century. (Courtesy Bernita Tickner.)

IMAGES
of America
THE STATE OF JEFFERSON

Bernita Tickner and Gail Fiorini-Jenner

ARCADIA
PUBLISHING

Published by Arcadia Publishing
Charleston SC, Chicago IL, Portsmouth NH, San Francisco CA

Printed in the United States of America

Library of Congress Catalog Card Number: 2005934843

For all general information contact Arcadia Publishing at:
Telephone 843-853-2070
Fax 843-853-0044
E-mail sales@arcadiapublishing.com
For customer service and orders:
Toll-Free 1-888-313-2665

Visit us on the Internet at www.arcadiapublishing.com

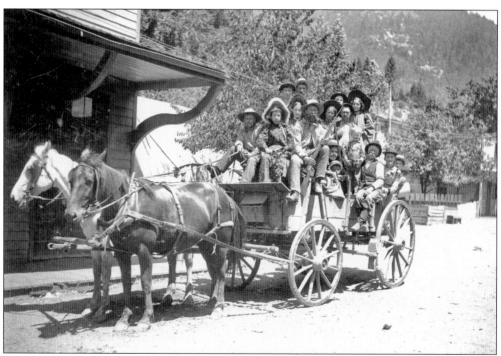

A wagonload of schoolchildren and young adults in Sawyers Bar is ready to leave town. Located on the Salmon River, Sawyers Bar was a rich gold-bearing area and continued to be a center of mining and packing activity into the 1900s. Because of the rugged terrain, a substantial road was not built into neighboring Scott Valley until the 1890s. (Courtesy Betty Jane Young.)

CONTENTS

ACKNOWLEDGMENTS

A project like this cannot be completed without the generous help of many people. We want to thank those who took time to provide photographs, interviews, or support. First we thank our families, especially Thomas Tickner and Doug and Matthew Jenner. Next we want to express appreciation to Erin and Jeff Fowle; Desiree and Kyle Kaae; Hazel Davis Gendron; Liz Bowen; Lyle Sauget and Nolan's Printing; Daniel Webster and the *Pioneer Press*; Ralph Starritt; Cecelia Reuter and the Fort Jones Museum; June Severns; the Siskiyou County Museum and Historical Society; Jim and Mary Ellen Rock; Mike Hendryx; Richard Terwilliger; Gay Berrien; Mark Evans; Greg Greenhouse; Anita Butler; Euphemia Roff for her photographs; Jenny Morris; Noah's Adventures from Ashland, Oregon; College of the Siskiyous Library; Bill and Willo Balfrey; Peter and Georgia Wright; Larry (deceased) and Nancy Bacon; George (deceased) and Frances Wacker; William (Willie) Munson; Janet Davis; Shasta Cascade; Dunsmuir Chamber of Commerce; Yreka Chamber of Commerce; Darryll Smith; Synthea and Vernon Smith; William and Rosalie More; Port Orford Library; Walt Schroeder; Roberta and Don Alan Hall; Kyle Peterson; Caralee Scala; Pat Martin; Dick and Ellen Janson; Betty Holland; Beth Marie Butler; Bill Jones and the Chico State University Merriam Librarian; Terry Brown; Brian Petersen; Harry Lake; Mamie Smith; Gary Tickner; Gil Davies; Florice Frank; Kayla Super; Hank Mostovoy; Dave Scott and D. H. Scott and Company staff; Monica and Roy Hall Jr.; Joan Luce Akana; Rosie Bley; Jim Bley; Port Orford Lighthouse Museum; Alturas Library; Cheryl Baker, librarian, Trinity County Historical Society; Fred and Bernice Meamber; Everet Smith; Marilyn Bogue, Trinity County Chamber of Commerce; Ethel Steele; Eunice Steele; Sally LaBriere; Pacific Power; Shirley Fisher; Rick Francona; Betty Jane Young; T. B. Hewett; Ken Knight; Judith P. McHugh, Mike Lee, Regina McFall, and the United States Forest Service; Sara Spence; Arlene Titus; Frank Attebery; Sandi Tripp; Molly MacGowan; Naomi Lang; the Bancroft Library; Judy Bushy; Ralph Brown; Wayne Hammar and the Siskiyou County Tax Collector's Office; Jack and Nancy Berggreen; Tamar Dolwig; Tulelake Museum; Melanie and Ken Fowle; Christyne Jenner; Eric Teel and Jefferson Public Radio; KSYC; John Jenott; Candy Cook-Slette; Jacqueline "Jackie" Denny; Ric Costales; Charles Seaver; Tricia Laustalot; John T. and GloryAnn Jenner; Pat Peterson; Larry Smith; Vella Munn; Annette Tickner-Edwards; Linn Mills; Carol Samuelson and Southern Oregon Historical Society; Scott Valley Drug; June Reynolds Butler; and Erich Ziller.

We give a hearty thanks to our editor, Hannah Clayborn, and the Arcadia staff for their encouragement. Finally we salute those who seek to preserve the unique aspirations of the State of Jefferson.

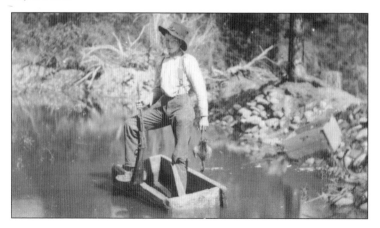

Typifying the independent spirit of those residing in the State of Jefferson, Danny Roff is pictured *c.* 1910, with a duck in one hand, a gun in the other. (Courtesy Bernita Tickner.)

INTRODUCTION

The State of Jefferson exists as more than a fantasy. According to Jim Rock, a Siskiyou County historian, the real "State of Jefferson" is characterized by a state of mind, not a state with borders. Today's Jefferson staters can be found in counties along the Pacific Coast, the Nevada state line, down in the Sacramento Valley, or up in central/eastern Oregon. Jefferson's struggle for statehood, however, is firmly planted in history. The first legal attempt at statehood occurred in 1852, when a bill was introduced to the California State Legislature at Vallejo. Though the bill failed, the notion did not, as noted in the January 14, 1854, edition of *The Mountain Herald* (Yreka, California):

> The citizens of the County of Siskiyou and State of California are requested to meet at the Yreka Hotel, in Yreka, on Saturday evening, the 14th of January next, at 6 o'clock p.m., for the purpose of taking measures to secure the formation, at an early date, of a new Territory out of certain portions of Northern California and Southern Oregon; and also to appoint delegates to a general convention for the same purpose, to be held at Jacksonville on the 25th of January next.

The declaration was signed by 23 men, including pioneers E. Steele, C. McDermit, M. B. Callahan, M. Sleeper, J. M. Shackleford, W. Davidson, and A. V. Gillett. In 1859, gold miners from the same borderline counties tried to maneuver state lines to avoid paying taxes. Petitions were circulated calling for the establishment of a county with names such as Klamath, Shasta, or Jackson. In 1860, Oregon tried to claim part of California by stepping 12 miles over the border, before Lieutenant Williamson established the northern boundary at 42 degrees north. Almost 50 years later, on March 31, 1910, in a letter addressed to the editor, Jefferson was mentioned as the possible name for a new state. C. K. Klum wrote the following:

> We have had men who exhibited a wisdom and prescience for our welfare that places us under a debt of gratitude, and their names should be given to our new states. Jefferson, in accepting Bonaparte's offer for the sale of the Louisiana Purchase without any constitutional authority, as he admits, for doing it, placed us under such obligation. Acting without loss of time, he at once organized and sent off the Lewis and Clark exploring expedition to cinch and bind the bargain.

In 1935, John Childs, a Crescent City judge, declared himself governor of a new state, as a protest against poor roads, neglect, and perceived injustice meted out by Sacramento. From this simple protest arose a more formalized "revolt," which began in Port Orford, Curry County, Oregon, now the recognized birthplace of the State of Jefferson movement. Mayor Gilbert E. Gable and others stormed into the county courthouse claiming that the natural resources of Oregon's coastline and the Siskiyou ranges had been neglected for far too long, and that Curry County should be transferred from Oregon to California. Perhaps to appease the crowd, the judge appointed a commission to study the likelihood of annexation. Gable immediately sent a letter to California's governor, Culbert L. Olson, who responded with modest enthusiasm. Oregon's attorney general also responded, saying that Curry County "could annex itself to a dry lake" if it so desired. Nonetheless, Gable appointed himself interim governor and announced his platform: the new state would not impose sales taxes, income taxes, or liquor taxes, but would rely on its resources as well as a healthy red-light district to bring in revenue. John Childs joined the effort. The concept of a 49th state so appealed to Yreka, Siskiyou's county seat, that the chamber of commerce persuaded the board of supervisors to consider it. Yreka then became the designated state capital. The Yreka 20-30 Club drafted a proclamation of independence

and staged a protest along Highway 99. The name Jefferson was selected after the *Siskiyou Daily News* ran a contest. J. E. Mundell of Eureka, California, submitted the winning name. A seal depicting a mining pan etched with two Xs—signifying the double cross by Salem and Sacramento politicians—was created. It is still used on flags, banners, and memorabilia by "residents of the State of Jefferson." Articles, editorials, and letters appeared in local papers and large publications, including the *San Francisco Chronicle* and *Examiner* newspapers and *Life* and *Time* magazines. Writers, photographers, even newsreel companies documented the movement.

One young reporter, Stanton Delaplane of the *Chronicle*, interviewed residents. Braving deplorable roads and harsh conditions, he wrote a stirring series of articles that earned him a Pulitzer Prize. On December 4, 1941, an election for state governor was held. John C. Childs won. His inauguration was celebrated with a parade through downtown Yreka, led by a bear named Itchy, a rally, and speeches. But who could have foreseen the future? Three days later, on December 7, 1941, Pearl Harbor was bombed and the nation went to war.

Following World War II, the dream was reborn. Regional politicians, business people, and rugged individualists clamored for a fair share of their state's money and attention. Today the same notions are bandied about, and occasionally a headline sends a ripple through the mostly small towns that make up the region. But other evidence suggests that the dream lives on: Southern Oregon's PBS radio station is officially named Jefferson Public Radio; signs along Interstate 5 and local highways indicate they are part of the official "State of Jefferson Scenic Byway or Highway;" businesses sell Jefferson State memorabilia; and Etna Brewery, located on the historic site of Kappler's Etna Brewery in Etna, California, boasts that it is the official beer of Jefferson. There is a State of Jefferson Chamber of Commerce, although its meetings are more social events than political ones. The *Pioneer Press*, a Western Siskiyou County newspaper located in Fort Jones, California, is the official headquarters and flies the "state" flag daily. Most important are the attributes of this enduring, mythical State of Jefferson. From its ruggedly beautiful natural wonders to its turbulent history and colorful characters, Jefferson inspires residents to question their destiny and visitors to remark on the independent "Jeffersonian" state of mind.

In 1904, four people scaled Mount Shasta with the first horse to climb the summit. Seated on the horse is Alice Cousins (known as Alma). Accompanying her were Tom Watson, the guide, W. S. Valentine (who took the photograph), and W. B. Beem (who owned the horse, Old Jump Up). Old Jump Up was not the first animal to climb the peak, however. Two mules, Dynamite and Cropper, ascended on September 10, 1883. (Courtesy Bernita Tickner.)

One

THE ROAD OF A THOUSAND WONDERS

Climb the mountains and get their good tidings.
Nature's peace will flow into you as sunshine flows into trees.

—John Muir

Diversity in the State of Jefferson is not only reflected in its people; it is most clearly reflected in its geography. Geologists suggest that early on, a significant portion of the region was an immense island surrounded by an inland sea. Fossils of ancient reptilian creatures, in addition to horses, camels, and elephants have been found throughout Oregon and California. The giant peaks of the Cascade Range rose up more than 12,000 feet during later geological periods, and one, Mount Mazama, exploded 7,000 years ago, leaving breathtaking Crater Lake in its wake. The Coastal Range pushed up out of the sea, while the wild rivers of the region were created by the retreating water. Native American tribes later migrated into the area and they discovered a land covered with forests of conifers and hardwoods, as well as waterways teeming with salmon, trout, beaver, and waterfowl and rich valleys where elk, deer, bear, and cougar roamed. Natural wonders dotted the scenic landscape: ice caves, lava tubes, gorges, springs and waterfalls, alpine and lowland lakes, and broad, high deserts.

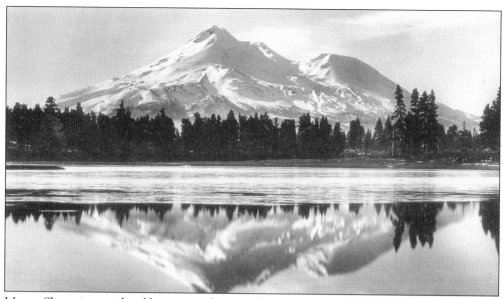

Mount Shasta is considered by many to be one of seven "sacred" mountains and can be seen for more than 100 miles in every direction. When naturalist John Muir first glimpsed it in 1874, he wrote, "I was fifty miles away and afoot, alone and weary. Yet all my blood turned to wine, and I have not been weary since." (Courtesy Nolan Printing.)

The Klamath River runs wild through the heart of the State of Jefferson. It is the largest of California's North Coast rivers, stretching over 200 miles from its mouth to the Oregon border. It empties into the Pacific 60 miles north of Eureka and 20 miles south of Crescent City, right off Highway 101. Fishermen love the Klamath, with its runs of king and silver salmon, steelhead, and resident trout. (Courtesy Liz Bowen.)

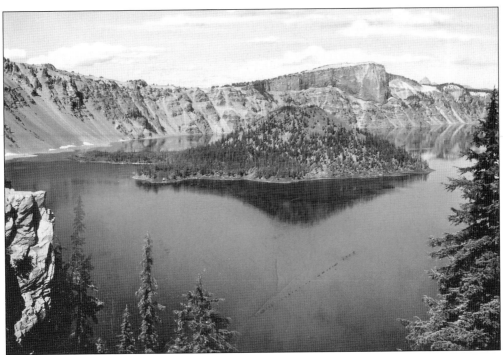

Crater Lake National Park in Oregon is located on the site of an extinct volcano, Mount Mazama, in the northwestern quadrant of Klamath County. It is Oregon's only national park. Known for its sterling blue color and rugged setting, the lake is about six miles wide and seven miles long, but is considered one of the deepest lakes in the nation at 1,932 feet. (Courtesy Nolan Printing.)

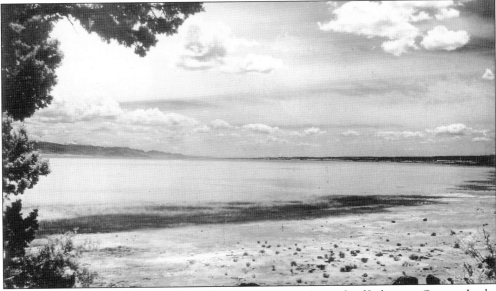

Goose Lake, situated half in Oregon and half in California, is south of Lakeview, Oregon. In the early days, the lake covered more area and, for a time, there was a town called Fairport nearby. Following the gold rush, it became a ghost town. Goose Lake was also an important landmark along the Applegate Trail. (Courtesy Bernita Tickner.)

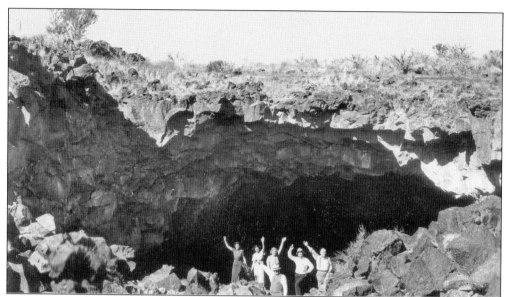

The Lava Beds National Monument is located in Tulelake, California. According to scientists, centuries ago a group of volcanoes erupted in the Klamath Basin. As a result, a 72-square mile area was covered with molten rock, creating a honeycomb of caves and rocky outcroppings, which is now the monument park. There are reportedly more than 500 lava tubes in the monument. (Courtesy Gail Jenner.)

The Tulelake National Wildlife Preserve is located within the Pacific Flyway for migrating waterfowl. The managed wetlands attract thousands of birds, including birds of prey, each year. The preserve is located only a few miles from the Oregon border and 30 miles south of Klamath Falls, Oregon, not far from Klamath Lakes. Upper Klamath Lake is one of the largest natural lakes in Oregon, and both are important to wildlife preservation. (Courtesy Bernita Tickner.)

Medicine Lake is located in the center of what was once Medicine Lake Volcano, a broad shield volcano that is actually larger than Mount Shasta in total mass. It is the largest volcano in the Cascade Mountain Range. When the original volcano's center collapsed, it created a basin six miles long and four miles wide. Not far from here is Glass Mountain, one of the largest obsidian glass flows in the West and an important resource for early local tribes. (Courtesy Bernita Tickner.)

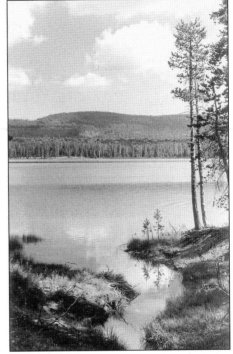

Castle Crags State Park is located six miles south of Dunsmuir in Siskiyou County, California. The pinnacles of granite range from 2,000 to more than 6,000 feet high. The Crags have been dated to over 170 millions years old. One important feature passing through the park is the Pacific Crest Trail. (Courtesy Nolan Printing.)

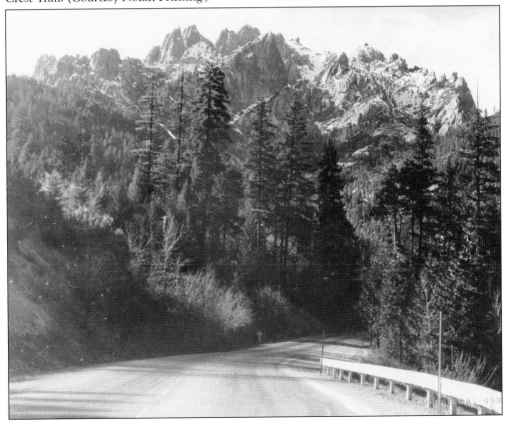

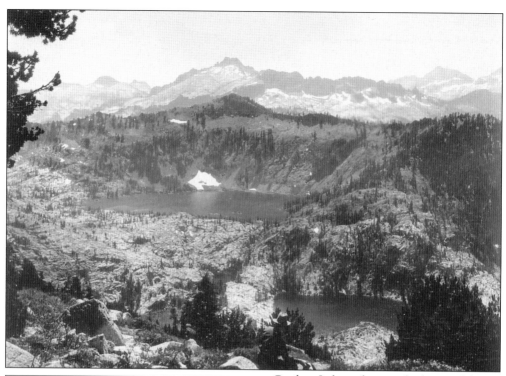

Caribou Lake is deep in the heart of the Trinity Alps and known for its dark blue water. It is one of three lakes in the area, the others being Lower Caribou and Snowslide. The terrain around Caribou Lake is rugged and offers spectacular views of Sawtooth Ridge. (Courtesy Bernita Tickner.)

The beautiful Trinity Alps Wilderness Area is located between Interstate 5 and Highway 101, northwest of Redding, and includes 500,000 acres of preserved wilderness. Some of the peaks rise 9,000 feet and trails to the lakes are steep and rugged, offering views of the surrounding mountainous regions. (Courtesy Bernita Tickner.)

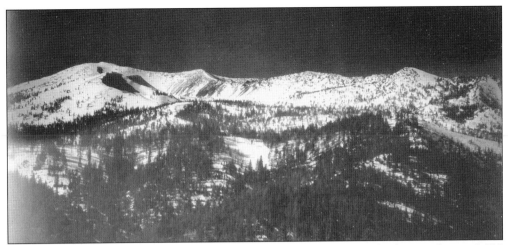

To the west of Mount Shasta lies the Eddy Mountain Range with peaks that reach over 9,000 feet, though they appear dwarfed by Mount Shasta. The Shasta River begins up in these mountains and flows north for about 50 miles through the flat Shasta Valley before emptying into the Klamath River. (Courtesy Nolan Printing.)

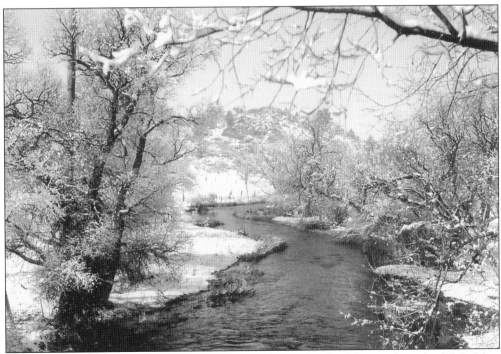

Shasta River meanders through Shasta Valley, benefiting farmland, livestock, and wildlife. Most private landowners have water-use rights dating back to the gold rush, but the Shasta irrigation water was adjudicated early in the 20th century. Farmers and ranchers are working to improve their water use every year. (Courtesy Bernita Tickner.)

Shasta Springs, located south of Mount Shasta, was one of the picturesque sites featured on the famed Shasta Route of the Southern Pacific Railroad. According to a tale retold by Joaquin Miller, the springs were formed when the Great Spirit learned the whereabouts of his lost daughter and ran with such joy and speed that the snow under his feet melted and streams began to flow, forming hidden courses of water. (Courtesy Bernita Tickner.)

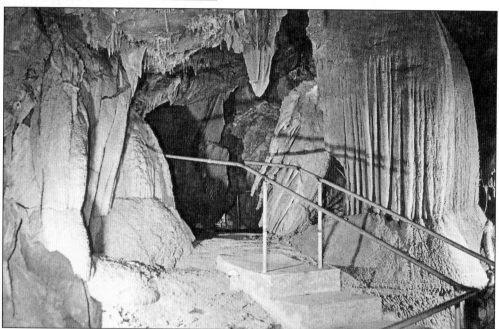

Lake Shasta Caverns was first known as Chalk Cave, then as Baird Cave. The move to preserve the caverns originated with Grace M. Tucker in 1955, when she purchased the land. In 1959, Grace and Roy Thompson, along with his brothers, formed Lake Shasta Properties, Inc. The caverns are still privately owned, but the land used for access roads, parking, boat docks, etc., are under a U.S. government lease through the Shasta-Trinity National Forest. (Courtesy Gail Jenner.)

Mount Lassen, located east of Redding and Red Bluff, California, is the southern-most peak in the Cascade Range. It was named for Peter Lassen who began guiding settlers into the area in 1851 via one of two pioneer trails—the Lassen and the Nobles Emigrant Trails. Early federal protection saved the surrounding area from heavy logging. (Courtesy Gail Jenner.)

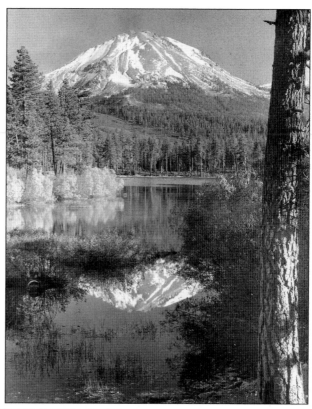

Employed by the Long Bell Division at International Paper Lumber Company, a forester views reforestation efforts around 1960, including the site of the 1850s town of French Flat in Scott Valley. Today the cutover land is growing a new crop for the future, a flourishing ponderosa pine plantation, under multiple-use forest management. Fruit Growers Supply Company now owns the property. (Courtesy Nolan Printing.)

Numerous trailheads and access trails, as well as the Pacific Crest Trail, lead to the steep, sheer, white marble rim in the Marble Mountain Wilderness Area. The surrounding 250,000-acre region was designated as one of California's first wilderness areas. There are more than 89 alpine lakes nestled throughout the rugged peaks of this mountain region. (Courtesy Nolan Printing.)

Kangaroo Lake is hidden in the mountains between Scott Valley and Mount Shasta, along the Gazelle Mountain Road. It is one of the few mountain lakes in Siskiyou County that is accessible by car and accessible to persons with disabilities. At a 6,500-foot elevation, the lake is generally open May through October. (Courtesy Annette Tickner-Edwards.)

First discovered in 1874, the Oregon Caves, often called the Marble Halls of Oregon, are located in the Siskiyou Mountains along the Oregon Historic and Scenic Highway, east of Cave Junction. One important visitor, Joaquin Miller, campaigned to protect the caves, and in 1909, President Taft designated the 480-acre area as a national monument. Visitors began flocking to the site after the highway was built around 1922. (Courtesy Gail Jenner.)

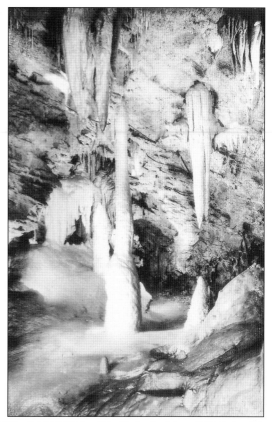

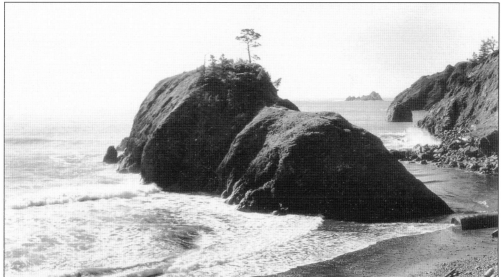

Port Orford, Oregon, located on the Southern Oregon coast 27 miles north of Gold Beach, has a long history as an important fishing and lumber port. It is also one of the oldest towns in Coos and Curry Counties. Battle Rock, pictured above, dominates the shoreline and was the site of a battle between the first white settlers and local Native Americans. This battle is reenacted each Fourth of July. (Courtesy Gail Jenner.)

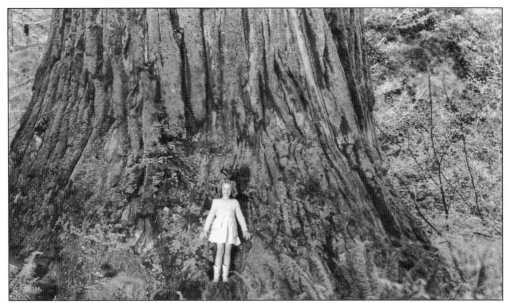

The Redwood National and State Parks, along Northern California's coast, are home to some of the world's tallest trees—old-growth redwoods. Redwoods live to be 2,000 years old and can grow over 300 feet high. Severe logging led to the preservation of these giants. The Prairie Creek Redwoods State Park, Del Norte Coast Redwoods State Park, Jedediah Smith Redwoods State Park, and Redwood National Park comprise 45 percent of all old-growth redwood forests remaining in California. (Courtesy Gail Jenner.)

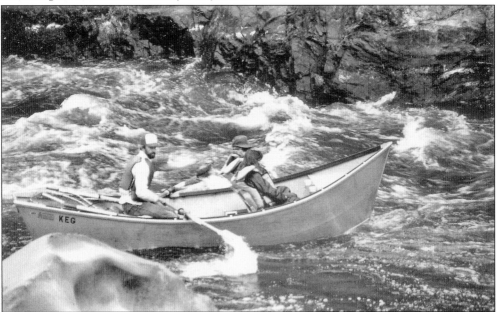

A Wild and Scenic River, the Rogue River in southwestern Oregon begins near Crater Lake in the Cascade Mountains and wends its way to the Pacific Ocean. The "wild" section of the Rogue offers 35 miles through the Wild Rogue Wilderness Area for whitewater rafting enthusiasts and is managed by the Siskiyou National Forest personnel. Here William More guides rafters down the rapids of the Upper Rogue. (Courtesy William and Rosalie More.)

Two

JEFFERSON'S
EARLY HISTORY

Oh, yes, the West was wild for a time, ruthless and tragic, but it was glorious, too, the greatest and swiftest movement of mass settlement across a continent in the world's history, resulting in clashes between good and evil forces that reverberate to this day. Americans know neither their country nor themselves unless they know the story of the old Wild West.

—Dee Brown

Local Native American tribes enjoyed thousands of years in what became the mythical State of Jefferson, linked by language, traditions, and trade. Then came the Spanish explorers, followed by Russian fur trappers, Hudson's Bay Company, and men such as Peter S. Ogden, Jedediah Smith, Joe and Stephen Meek, and Alexander R. McLeod. A few bold settlers came, forging trails like the Oregon and California Trails, the Applegate, the Lassen, and the Cold Spring Mountain Trail. When gold was discovered, miners rushed in, slapping together settlements that usually lasted only as long as the gold. They washed away mountainsides and changed the course of rivers, which led to violence between the newcomers and the Native Americans. Soldiers marched in and forts were established. Reservations were created and tribes dispersed. Meanwhile towns grew while roads, like the California-Oregon Stage Road and Pioneer Wagon Road, helped open up unsettled areas. Logging and ranching took hold, until the final leg of railroad connected Jefferson State to the rest of the nation.

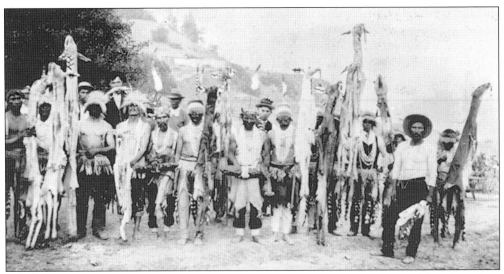

Tribes along the Klamath River and its tributaries held ceremonies every year, such as the White Deerskin and Jump Dances, which were tied to a ceremonial calendar. Dancers in the White Deerskin dance wore special regalia, including deer-hide kilts, dozens of dentalia necklaces, and wolf-fur bands around their foreheads. Bright woodpecker scalps decorated their heads. They carried poles with stuffed deer heads mounted at the end, and white or light deerskins draped below. (Courtesy Fort Jones Museum.)

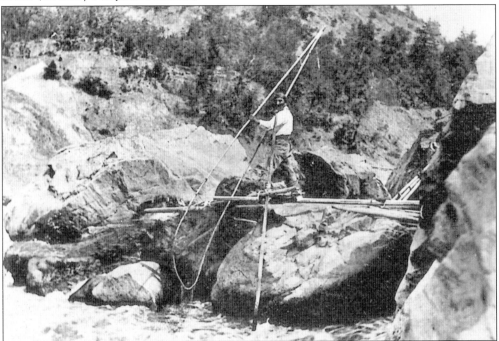

Long a tradition of the Karuk, this man is dip-net fishing for salmon and/or steelhead on the Klamath River, near Ishi Pishi Falls. Other fishing tools included spears, weighted nets, and traps. Salmon, along with eel and river trout, were diet staples. By smoking the fish, often over alder wood, they could be preserved. Salmon was and continues to be a major component of Karuk life and customs. This photograph was taken in the 1890s. (Courtesy Nolan Printing.)

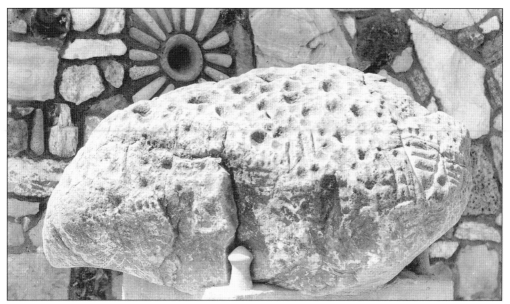

The Shasta Rain Rock, located now beside the Fort Jones Museum, was uncovered by a road crew working to widen the Klamath River Highway near Gottville, California. The boulder is a two-ton chunk of soapstone and stands two feet high. Believed to be buried by the Shastas in the late 1800s, the Rain Rock was covered to halt the severe winters they had been having. To leave it uncovered could cause harsh winter conditions. (Courtesy Fort Jones Museum.)

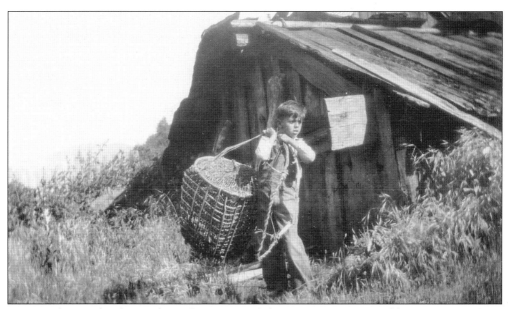

Young Robert Halsted, a student of Minerva Salisbury Starritt is pictured here c. 1929 in front of a traditional Yurok house made of planks. He carries an eel trap over his shoulder. Minerva served as a teacher at Morek for two years. (Courtesy Ralph Starritt.)

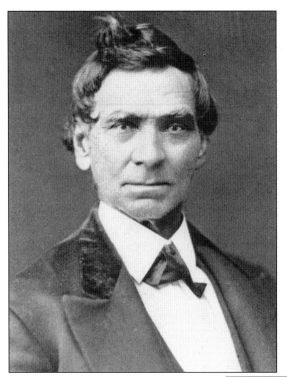

Lindsay Applegate was one of two brothers who pioneered the Applegate Trail into Southern Oregon, *c.* 1846. Lindsay and a party of men also crossed the Siskiyou Mountains in 1849 and mined a few days on the confluence of South Fork and East Fork of Scott River (later to become the site of Callahan). He is credited with being the first to mine in Siskiyou County. (Courtesy Southern Oregon Historical Society.)

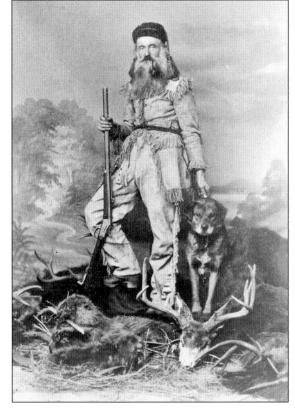

Stephen Meek, brother of the famous mountain man Joe Meek, is credited with the "discovery" of Scott Valley in Siskiyou County, first called Beaver Valley. He came to the area in 1836 with a party of trappers, led by Thomas McKay, another well-known mountain man. Later in life, Stephen Meek (and son George) returned to Scott Valley, where he spent his remaining years. He was buried in Etna Cemetery. (Courtesy Fort Jones Museum.)

Peter Lassen, pictured at right, and William Nobles led settlers over an alternative route into California that ran from the Humboldt River (in Nevada) to Shasta City at the northern end of the Sacramento Valley. Lassen, who emigrated from Farum, Denmark, is also credited with being the first man to bring the Masonic Charter to California in 1848. (Courtesy Bernita Tickner.)

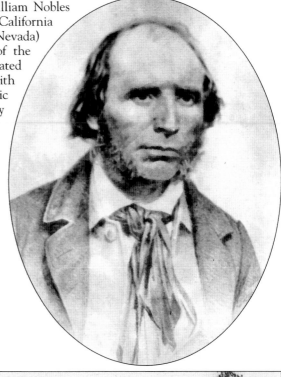

The original fort at Fort Jones, named for Colonel Roger Jones, was built in 1851 and abandoned in 1858. The only frame building to survive was the officers' quarters, which was moved into town and became the Reynolds' house. A number of famous soldiers began their careers at this outpost, including Gen. George Crook and Lieutenant Pickett. It is said that Ulysses S. Grant and Phillip Sheridan were assigned duty here, but never arrived. (Courtesy Fort Jones Museum.)

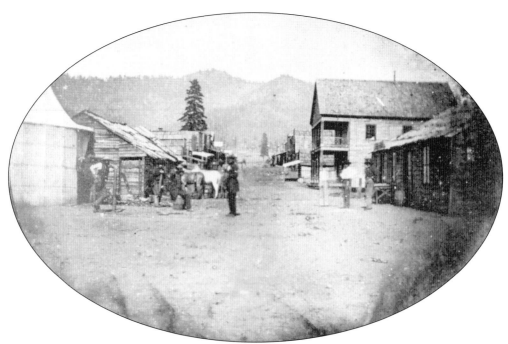

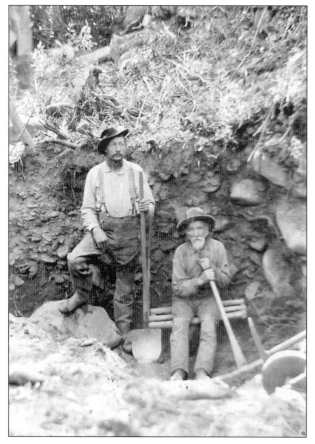

Above is an early view of Yreka, first called Shasta Butte City. Gen. Joseph Lane, who came to the area from Oregon, is credited with an early find of gold on Shasta River in 1850, near where Yreka now stands. From 1853 to 1857, Yreka's population grew to 5,000. As early as 1859, city streets and some residents boasted gas lamps. The "darling of the gold fields," young Lotta Crabtree came to Yreka and performed for the miners in 1856. (Courtesy Bernita Tickner.)

Two of the early South Fork of Salmon River miners, Theo Larch, standing, and William Henry George, sitting, pose for the photographer in the early 1900s. Mining along the South Fork began as early as 1850 and some important centers for the region included the towns of Cecilville, Petersburg, and the Forks of Salmon. (Courtesy Euphemia McNeill Roff.)

Pilot Rock, or Pilot Knob, was a landmark for emigrants as they crossed from Oregon into California or California into Oregon. The lowest and shortest passage through the mountains was a few miles west of the giant 1,000-foot rock. Later the railroad company thought it would tunnel through the massive stone, but soon abandoned the idea. Today's travelers pass over the summit at 4,310 feet, which is the highest point anywhere on Interstate 5. (Courtesy Gail Jenner.)

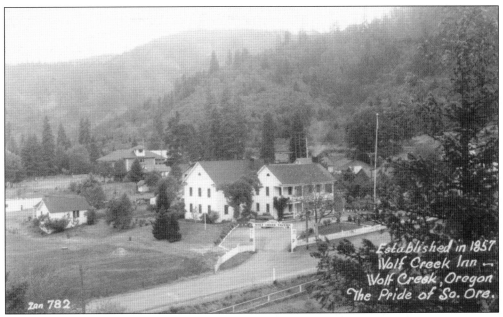

Established in 1857
Wolf Creek Inn —
Wolf Creek, Oregon
The Pride of So. Ore.

Zan 782

Wolf Creek Tavern, located 20 miles north of Grants Pass, Oregon, is listed in the National Register of Historic Places. The original inn was called Six Bit House, while the present-day tavern was built c. 1883 for Henry Smith. Wolf Creek was a stage stop on the 16-day journey from San Francisco to Portland and is the oldest continuously run hotel in the Northwest. Jack London was a frequent guest, as were Mary Pickford, Clark Gable, Carol Lombard, and others. (Courtesy Gail Jenner.)

Horace Gasquet was born in France and was an early pioneer of both Del Norte and Siskiyou Counties, investing money in a number of ventures. A bachelor for many years, he married Mrs. Fournier in a union that many believe is shaded in mystery. Gasquet died on January 22, 1896. The town of Gasquet was named for him. (Courtesy Hazel Davis Gendron.)

Chinese miners settled in almost every gold camp or town in Northern California and Southern Oregon, thus, most settlements had their own Chinatowns. Frequently the wood buildings burned down, often by accident, more often deliberately. Many Chinese worked as domestics or took on odd jobs, but at death, those who could arrange it had their bones returned to China. This form constitutes one man's attempt to establish residency. (Courtesy Fort Jones Museum.)

№. 23122

ORIGINAL.

UNITED STATES OF AMERICA.

Certificate of Residence.

Issued to Chinese _____, *under the Provisions of the Act of May 5, 1892.*

This is to Certify THAT _____ *Mar Yem* _____, a Chinese, now residing at _____ *McAdams Creek Cal* _____ has made application No. *4122* to me for a Certificate of Residence, under the provisions of the Act of Congress approved May 5, 1892, and I certify that it appears from the affidavits of witnesses submitted with said application that said _____ *Mar Yem* _____ was within the limits of the United States at the time of the passage of said Act, and was then residing at _____ *McAdams Creek Cal* _____ and that he was at that time lawfully entitled to remain in the United States, and that the following is a descriptive list of said Chinese _____ viz.:

NAME: *Mar Yem* AGE: *45 yrs.*

LOCAL RESIDENCE: *McAdams Creek, Cal*

OCCUPATION: *Miner* HEIGHT: *5 ft* COLOR OF EYES: *Dark brown*

COMPLEXION: *Dark brown* PHYSICAL MARKS OR PECULIARITIES FOR

IDENTIFICATION: *Scars on nose R cheek mole R temple Small eye*

And as a further means of identification, I have affixed hereto a photographic likeness of said _____ *Mar Yem* _____

GIVEN UNDER MY HAND AND SEAL this _____ *10th* _____ day of _____ *March* _____, 189*4* at _____

State of _____

[SEAL]

Collector of Internal Revenue,

2—1408

District of _____

28

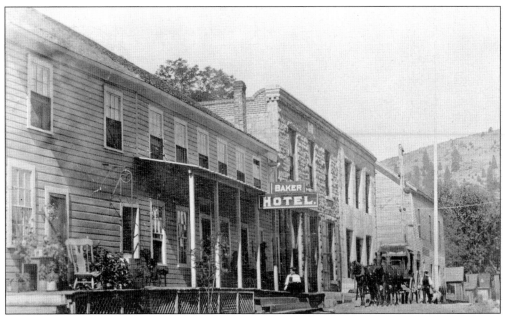

Callahan, California, was named for merchant Mathias Bernard Callahan, who owned stores in Trinidad and Yreka. As the story is told, while taking his family to Yreka by way of Trinity, and crossing the flooded East Fork of Scott River, Mrs. Callahan fell into the water. Though rescued by an Indian boy traveling with them, she went into labor and gave birth to a premature son. They settled nearby. (Courtesy Betty Jane Young.)

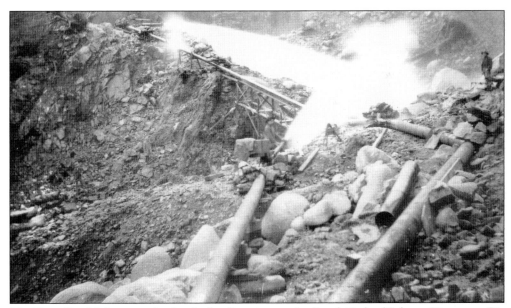

The Deep Bank Mine was the first hydraulic mine on the South Fork of Salmon River near Big Flat. The mine was discovered and worked by James Abrams, beginning around 1851. (Courtesy Euphemia McNeill Roff.)

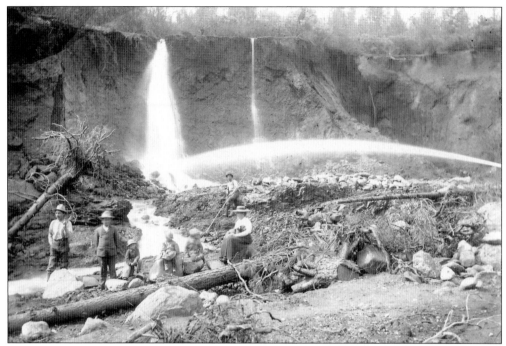

This hydraulic mine, known as the Summerville Mine, was located on Salmon River and operated for nearly a score of years under the supervision of George Spooner, who was part owner with Fred Smith and Alex Parker of Etna. Charlie Roff stands at left (with suspenders). The others are unidentified. (Courtesy Bernita Tickner.)

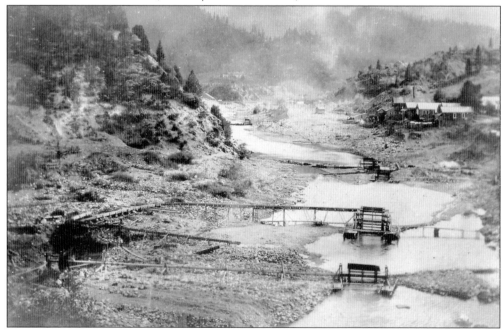

These are Chinese current wheels in Scott River in the 1890s. The flat area to the left of the river was worked by some 500 Chinese miners. Note Scott Bar on the right. In the winter, these wheels were often washed out and had to be rebuilt. (Courtesy Hazel Davis Gendron.)

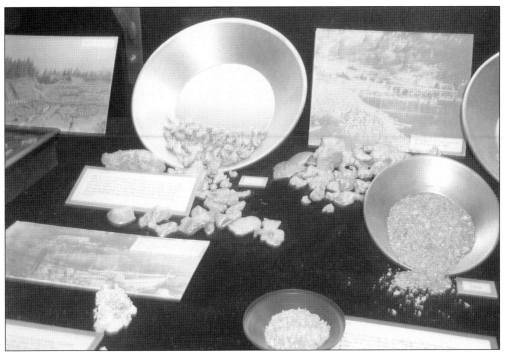

Siskiyou County's gold display, housed in the county courthouse foyer, is worth about $1 million. Inside are $1,000 chunks of quartz rock, gold dust, jewelry, and other mining artifacts. The most valuable items include a $33,000 gold nugget discovered "in a pile of discarded shavings near Hawkinsville" and the $28,000 "Shoe Nugget" found in 1913 near Scott River. (Courtesy Wayne Hammar and the Siskiyou County Tax Collector' Office.)

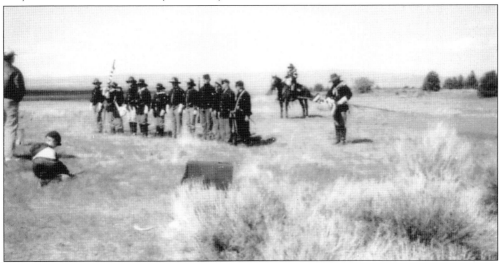

This is a reenactment of the Modoc War. Scarface Charley, a chief of the Modocs, is considered to have fired the first shot at the Battle of Lost River, the official name of the infamous Modoc War. After the war, Captain Jack, or Kientpoos, and three other warriors were executed for the murder of Gen. Edward Canby and Rev. Eleazer Thomas, two peace negotiators. Scarface Charley spent a year in Oklahoma, then returned home where he became a well-known craftsman. (Courtesy Bernita Tickner.)

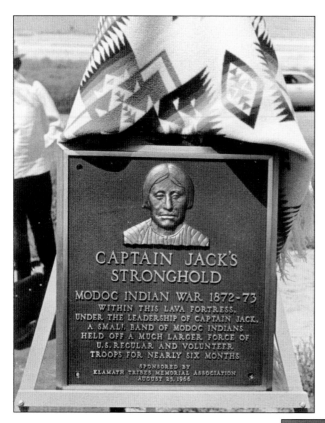

Captain Jack's stronghold was the scene of the Modoc Indian War from 1872 to 1873. A small band of Modocs, led by young Kientpoos, or Captain Jack, held off army troops sent from Fort Jones for more than six months. In the end, Captain Jack was double-crossed by some of his own men. He was later hanged. (Courtesy Gil Davies.)

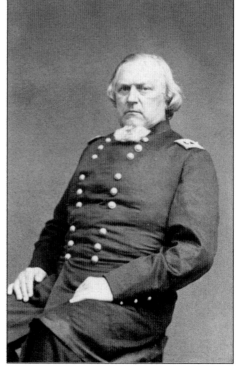

During the Indian War of 1853, Southern Oregon raised six companies of volunteers under a number of captains, including R. L. Williams, John Lamerick, John F. Fuller, Elias Owens, and W. W. Fowler. Pictured here is Bradford R. Alden of the 4th U.S. Infantry, who traveled north from Fort Jones, California, with 20 regulars and was given command of the combined forces. In July 1856, Tyee John and his warriors finally "threw down the hatchet." (Courtesy Fort Jones Museum.)

Bret Harte lived in various parts of the Jefferson region off and on during the gold rush. In 1860, while living in Arcata, he worked as a journalist and exposed a massacre that had been committed against the Wiyot on Indian Island. Most of the victims had been women and children. In raising the awareness of Americans around the country, he raised the ire of local citizens who ran him out of town. (Courtesy Fort Jones Museum.)

Peter Britt, who supposedly arrived in Jacksonville in the 1850s with $5 and a wheelbarrow of photographic equipment, was an artist, entrepreneur, horticulturalist, and most importantly, an avid photographer. His photographs present an important record of early Jacksonville and Southern Oregon history. Jacksonville's Britt Festival, an annual summer music festival, was established in his honor. (Courtesy Bernita Tickner.)

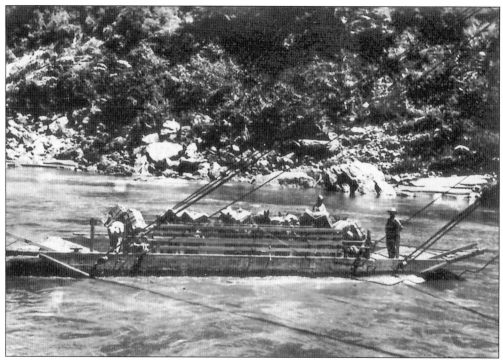

Martin's Ferry was an important stopping point as well as a crossing for travelers and packers. Downriver from Happy Camp, California, the ferry transported people, stock, and supplies across the often tumultuous Klamath River. Martin's Ferry was named for John F. Martin, who settled there in 1854. Note the loaded pack animals on board in this *c.* 1890s photograph. (Courtesy Hazel Davis Gendron.)

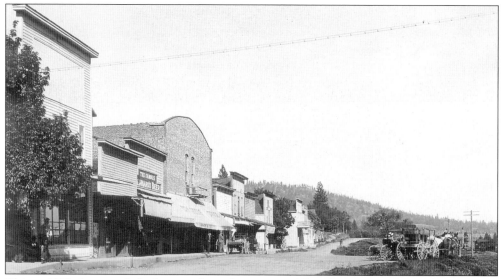

This *c.* 1920 photograph looks east, from the corner of Fourth Street and Fourth Avenue in Gold Hill, Oregon. Gold Hill was founded in the early 1800s by gold miners. Gold Hill is also the home of the famous Oregon Vortex, a strange phenomenon involving gravitational pull. (Courtesy Bernita Tickner.)

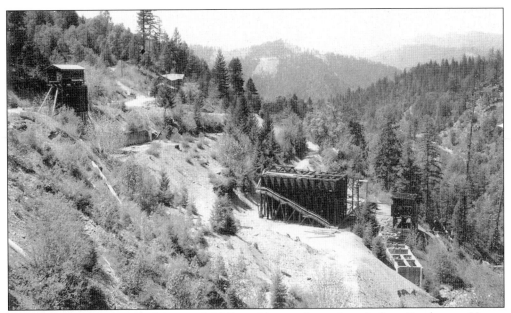

The Grey (or Gray) Eagle Mine and Mill cookhouse, located up Indian Creek near Happy Camp, is shown here with the mill in the background. This mine was worked during both world wars. Sometime later, the cookhouse was razed and the lumber used to build the Happy Camp Kingdom Hall. (Courtesy Arlene Titus.)

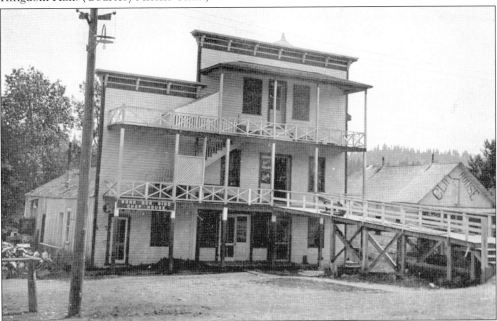

The Wong Ock Sing Chop House was an early Chinese establishment in Etna, California, located across from the old Bradley Building on Main Street. Few photographs remain to document its existence. As with so many early buildings, this three-story structure either burned down or was torn down. Etna's Chinatown was never large and most of its residents eventually left and returned to China. Only a few remained behind to serve as domestic servants. (Courtesy Bernita Tickner.)

John Daggett served as assemblyman from Klamath and Del Norte counties in 1859 when a measure, signed by 10 prominent Yreka citizens, was submitted, authorizing those residing north of the 40th parallel to withdraw from the State of California and organize a separate state. Daggett recommended postponement of the measure. Daggett owned the Black Bear Mine on Salmon River, which produced $3 million in gold between 1860 and 1906. He went on to become lieutenant governor of California and superintendent of the U.S. Mint in San Francisco. (Courtesy Fort Jones Museum.)

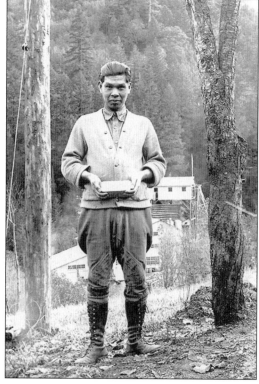

Known only as Kim, this well-liked Chinese cook worked at King Solomon's Mine on the South Fork of the Salmon River in California. He is seen here holding a gold brick, a proud display of gold produced by the mine. (Courtesy Siskiyou County Museum.)

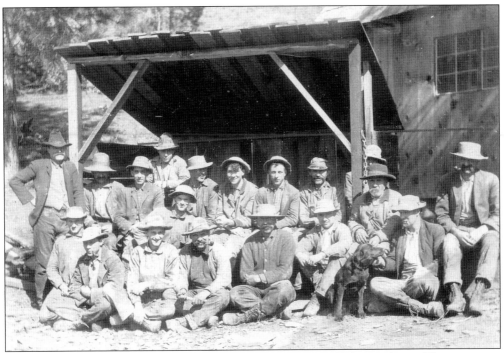

Here is the Golden Eagle Mining crew, c. 1908, taking a well-deserved rest. The mine was located up Indian Creek, near Hooperville, California. William Tickner is located at the far right. The others are unidentified. (Courtesy Bernita Tickner.)

Sawyers Bar was an important center during the hubbub of mining and packing days, but slowly dried up as gold became less abundant. One important landmark is the small Sawyers Bar Catholic Church, built in 1857 by subscription and volunteer labor, under the direction of Fr. Florian Schwenninger, a missionary priest. The church was built on valuable mining ground and when offered $40,000 for the parcel, the members staunchly refused. (Courtesy Bernita Tickner.)

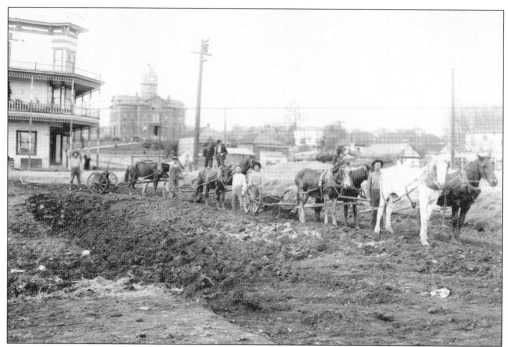

Around 1909, horse teams rented out by John Diestelhorst (standing center), were used to clear land for a new building site in Redding, California. Next to Diestelhorst is his son George. As early settlers in Shasta County, they owned much of the land bordering the river in Redding. Note the county courthouse in the background. (Courtesy Dave Scott.)

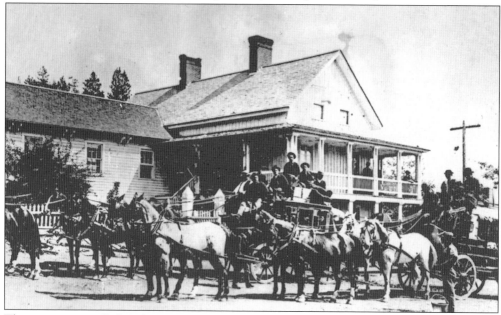

This stage stop, called Cole Station, was built and operated by Rufus Colt in 1859 near Hilt, California, and served as an important stopping place for stages on the Siskiyou Wagon Road. It was closed as a stage stop upon completion of the Oregon and California Railroad. On December 17, 1887, the last southbound stage left. (Courtesy Nolan Printing.)

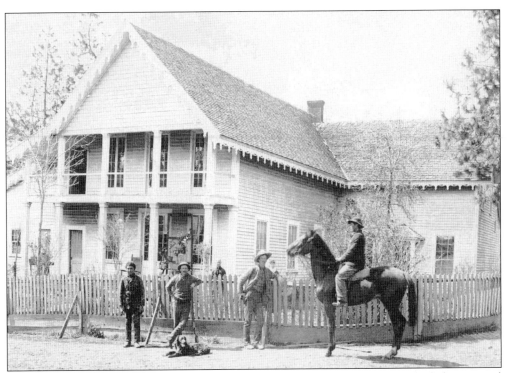

Asa Howard, an early resident of Mugginsville, California, built an inn called the Howard House, as well as a store. He also served as the unofficial postmaster. In January 1855, his son Scott Howard was born, making him the second white child born in Scott Valley. Today the deteriorating structure is being dismantled. (Courtesy Fort Jones Museum.)

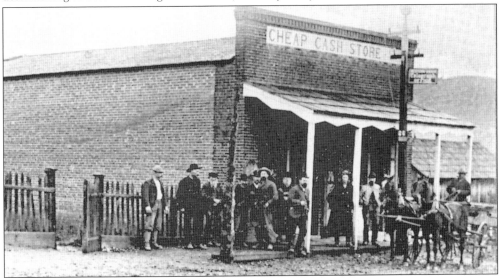

The Cheap Cash Store was built in 1853 in Henley, Siskiyou County, by Merritt Brothers. It was sold in 1881. Pictured in this 1888 photograph, from left to right, are (first row) John Brady, William Smith, unidentified, Thomas Jones, and unidentified; (second row) the Wagner boy, unidentified, unidentified, Abraham Schultz, Dick Reese, unidentified, Elmer Niles, and Joe ?. (Courtesy Nolan Printing.)

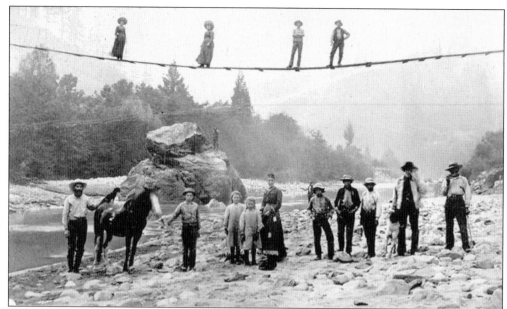

A "swinging bridge" crosses the South Fork of Salmon River near Yocumville. On the bridge, from left to right, are Grace Fyfield Lyons, Ollie Hobson, Will Balfrey, and James Riley. On the rock are George Mitchell (standing) and Joe Cannon. Jeff Wayne is seen fishing. Pictured on the beach, from left to right, are H. E. Dulabon (standing by horse and dog), Will Fyfield, Winnie Fyfield Clarke, Lyda Fyfield Miller, Mrs. J. T. P. Dulabon, Amos Orcutt, Henry Orcutt, Alec Walter Carnie, John Nelson (with dog), and Fritz Monhart. (Courtesy Fort Jones Museum.)

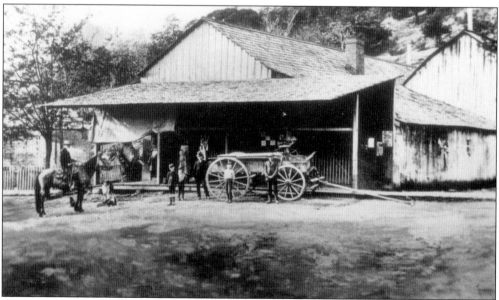

This was the old meat market, located in Shasta, west of Redding, California. On horseback sits Edward Ricketts Jones. During this time, Shasta was known as the "Queen City" and was the center of commerce and activity. It is said that as many as 100 pack trains pulled into Shasta in a single evening to be loaded up and sent into the northern mines. (Courtesy Dave Scott.)

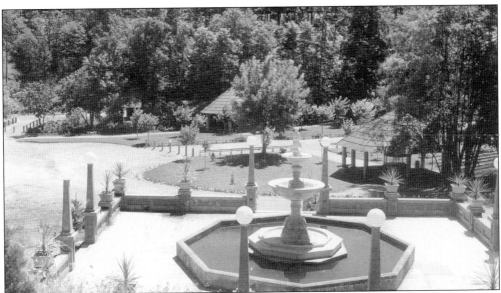

Sponsored by the Women's Civic Improvement Club in 1908, Lithia Park in Ashland, Oregon, is a 100-acre park that extends from The Plaza along Ashland Creek up to the foothills of Mount Ashland and the nearby ski resort. Lithia's mineral waters made the park and city a popular destination. The park was designed by John McLaren, who also designed the gardens at San Francisco's Golden Gate Park. Today the famous Oregon Shakespeare Festival grounds border the park. (Courtesy Bernita Tickner.)

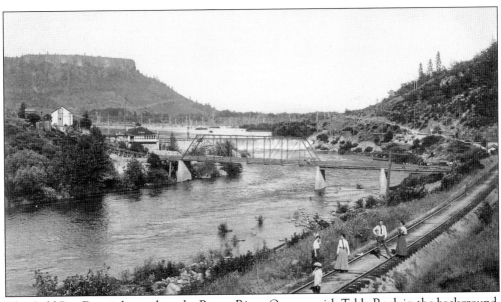

The Gold Ray Dam is located on the Rogue River, Oregon, with Table Rock in the background. This bridge was eventually destroyed by flood. The Condor Power Company built a line in the late 1800s to Ashland, Oregon, to supplement the city's electric supply. Jackson County assumed ownership of the dam in the 1970s, but the fate of the dam is now in question. Table Rock was an important site during the Indian Wars. (Courtesy Bernita Tickner.)

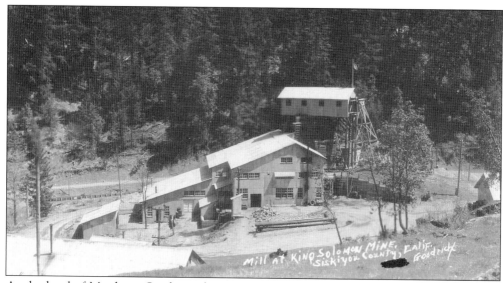

At the head of Matthews Creek on the South Fork of the Salmon River was King Solomon Mine. Discovered by Harvey Bowerman around 1894, it remained active into the 1890s as a hard-rock mine operating with an eight-stamp mill, plus a steam-powered Huntington mill. The mine closed but was reopened from 1932 to 1940 by the King Solomon Mining Company, employing the open-cut mining method. (Courtesy Bernita Tickner.)

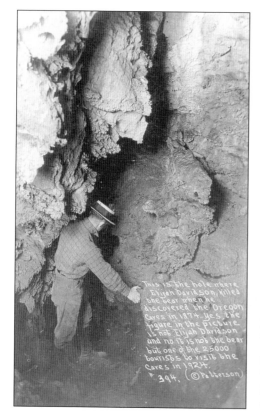

In 1874, Elijah Davidson, 24 years old, was hunting a bear when his dog Bruno disappeared into a cave. Davidson stopped at the dark and foreboding entrance where he saw nothing, but heard the excited howl of his dog. He finally entered and found himself in the amazing caverns now known as the Oregon Caves. When Joaquin Miller, the "poet of the Sierras," visited the caves in 1907, he called them the Marble Halls of Oregon. (Courtesy Gail Jenner.)

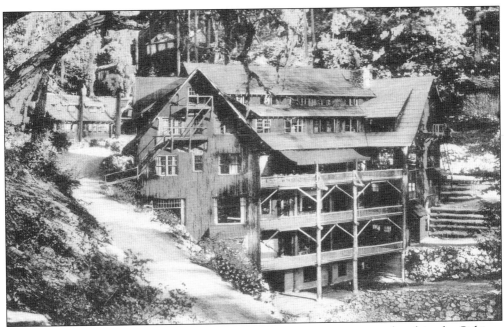

The Chateau at Oregon Caves National Monument is a rustic six-story hotel in the Siskiyou Mountains next to the entrance to the cave. The buildings were all constructed between 1923 and 1941, and the lodge has a wood-frame superstructure with enormous post-and-beam interior supports. (Courtesy Gail Jenner.)

One of the most photographed Victorian houses in California is the William Carson mansion in Eureka. The designers, Samuel and Joseph Newsom, were highly respected San Francisco architects. It took 100 men more than two years to complete the mansion. In addition to using redwood, Carson imported 97,000 feet of white mahogany from Central America. Owned by the Carson family until 1950, the mansion was eventually sold to the Ingomar Club. (Courtesy Gail Jenner.)

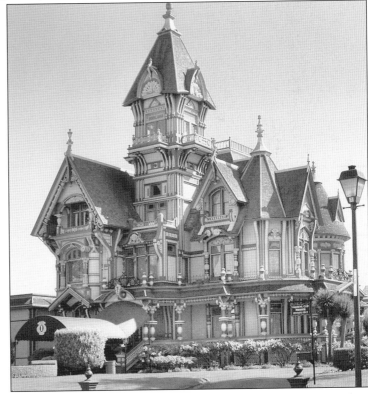

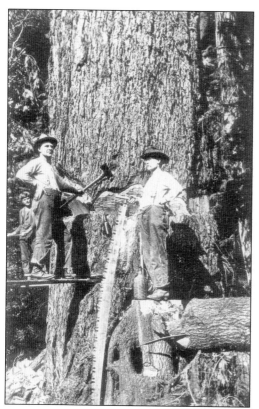

Coos County was formed in December 1835 and originally included the coastline from the California border north to within eight miles of the Umpqua River. The area was home to several tribes, including members of the Coos, Coquille, and Rogue River Indians. The primary resource was timber. Here lumberjacks are using a springboard to cut a giant fir located in Coos County along the Oregon Coast Highway. (Courtesy Gail Jenner.)

In the early 1900s, trees were still cut down with handsaws and sweat, often called "Swedish steam," but the key to making money was to remove trees as quickly and cheaply as possible. From spring through fall, timber fellers downed trees and sent the logs to the mills, which popped up along rivers as well as up and down the coast. (Courtesy Nolan Printing.)

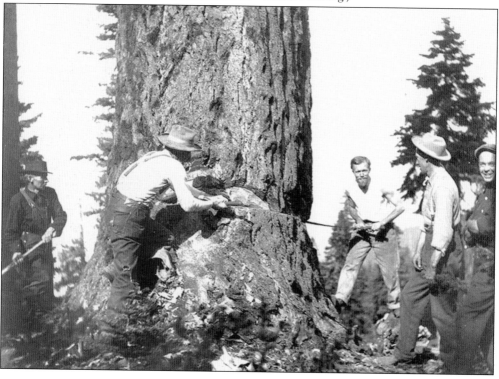

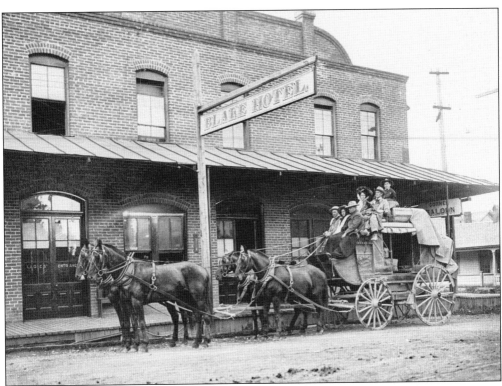

The Blake Hotel in Etna served as a link in the stagecoach line running in and out of Scott Valley, California. Bill Balfrey tells the story that every so often the men (and boys) would go on a pigeon hunt, after which the women would put their washtubs out on the sidewalk and pluck and clean the birds. Apparently the Blake Hotel served the birds as "squab." (Courtesy Bernita Tickner.)

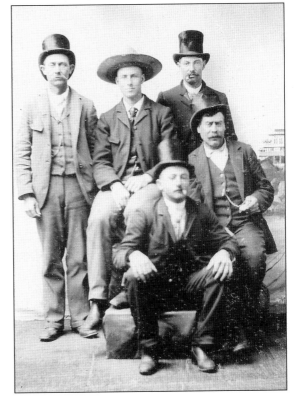

These Siskiyou "jehus" (stage and team drivers) are clean, scoured, and well dressed, ready for a holiday in San Francisco and the Cliff House. The only identified driver in this photograph, which was taken from a tintype, is Frank Lloyd, top right. (Courtesy Bernita Tickner.)

This was the Redding to Weaverville Stage in 1905 as it passed near French Gulch. One famous stage robbery involved the Weaverville Stage in 1892. After $5,000 was stolen and Amos "Buck" Montgomery, the messenger/guard, was killed, a posse was formed and the first of the two bandits, Charles Ruggles, caught. John Ruggles was captured six weeks later. The handsome brothers were lynched by a mob and left to hang not far from the railroad tracks. (Courtesy Gail Jenner.)

Because snow in the mountains was deep, horses and mules wore snowshoes to keep from sinking. This snowshoe measures 12 inches by 10 inches and weighs seven pounds. Placed on all four feet, they were first soaked in boiled linseed oil and then "doped" with a mixture of wax and pine tar. Most animals learned to swing their feet to walk, but some never learned. Those animals were pastured out in winter. (Courtesy Bill and Willo Balfrey.)

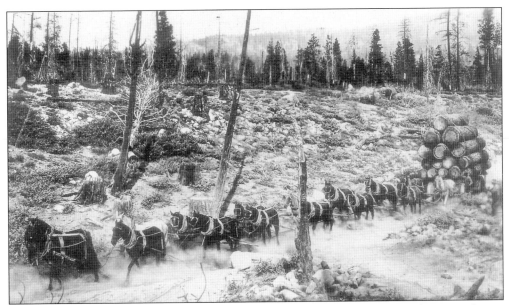

Moving felled trees was a mighty job for everyone. In the beginning, teams of oxen, mules, or horses dragged the enormous logs out of the woods on skid roads built of poles. Animals were the primary power source for many years and would not be replaced until steam power was introduced in the 1880s and even then, many still relied on animals. This photograph dates to 1895. (Courtesy Gail Jenner.)

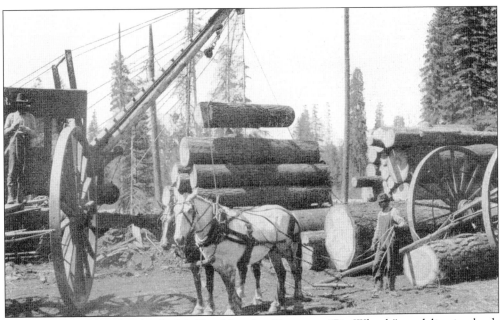

In this photograph, taken by the McCloud Lumber Company, "Big Wheels" are delivering loads of lumber at a landing, then loading the logs onto cars. According to an early printing, the McCloud Company manufactured "white and sugar pine lumber, lath and mouldings, beveled siding, sash and door cuttings, and box shooks." (Courtesy Gail Jenner.)

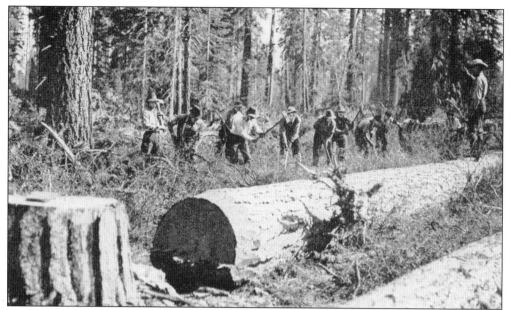

Here the men are "swamping," in other words preparing the way for the "Big Wheels," which will be used to move the enormous logs already felled. This photograph was taken by the McCloud Lumber Company, which advertised that its sawmills, planing mills, etc., covered over 700 acres. (Courtesy Gail Jenner.)

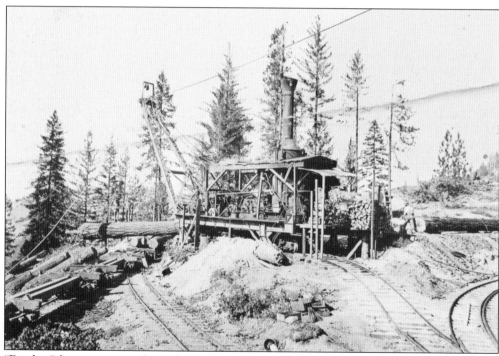

"Donkey" logging was used mostly for logging on steep terrain. However, the donkey logging method that used a steam engine for power was actually invented by John Dolbeer of Dolbeer and Carson Lumber Company for use in the redwoods. (Courtesy Hazel Davis Gendron.)

This is Abrams's log cabin, located at Lakeview. James Abrams began mining in the South Fork-Salmon River region around 1852, then moved down to Lakeview and built a cabin. He returned east for his bride. His brother Frances packed for a time at Petersburg before moving in c. 1889 to Lakeview, where he also built a house. Frances never married. Both were buried in the Abrams cemetery at Lakeview. (Courtesy Bernita Tickner.)

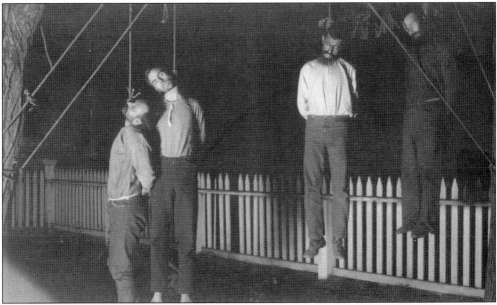

These men were taken out of jail by vigilantes and hung from an iron rail placed between two locust trees: Lawrence Johnson, who killed his wife; William Null, who shot Henry Hater; and Luis Moreno and Garland Stemmler, who murdered two men during a robbery. Moreno went to his death stoically. Stemmler, the youngest at 19, said, "Tell my brother to tell Mother I'm innocent." There were no murders in Siskiyou County for another 19 years, and the locust trees died. (Courtesy Fort Jones Museum.)

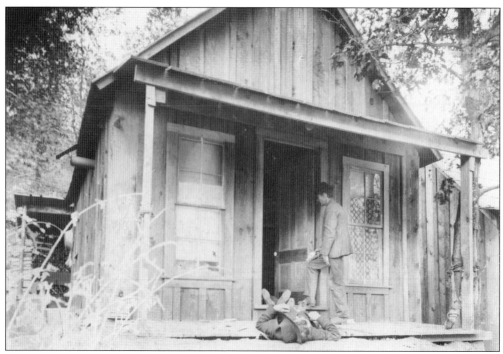

After robbing a stage, the bandit, William Harrall, made his way back to his cabin at Delta in Shasta County, California, where his wife awaited him. He was followed by Siskiyou County deputy sheriff William Radford and Shasta County undersheriff G. H. Stewart. When the men knocked on the door, Harrall opened it, then shot and mortally wounded Deputy Radford. In the ensuing exchange, Undersheriff Stewart killed Harrall. Stewart stands in the doorway, the deputy at his feet. (Courtesy Fort Jones Museum.)

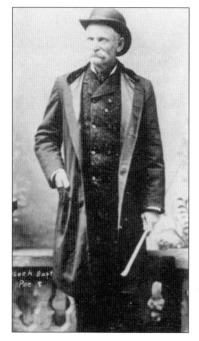

California's most famous bandit, Black Bart, a.k.a. Charles Boles, successfully robbed 28 Wells Fargo stages in California, with only a plugged shotgun. He robbed 11 stages in Siskiyou, Shasta, and Jackson Counties. Also called the "poet bandit," Boles left poetry at the sites of several holdups. James Hume, Wells Fargo's detective, finally captured the handsome and polite thief in 1883. Boles served four years in San Quentin before his release and eventual disappearance. (Courtesy Gail Jenner.)

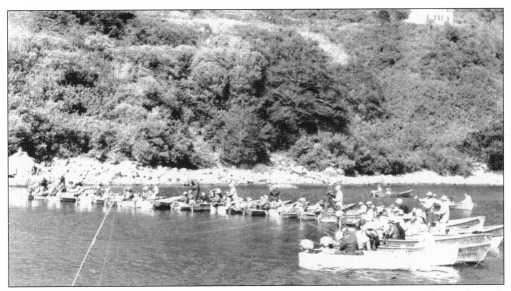

Sport fishermen line up across the mouth of the Klamath River, *c.* 1920, catching chinook salmon. At times, the fish were so thick in the tributaries that men reportedly were able to walk across their backs. Today fish are returning to the rivers in record numbers as environmentalists, tribes, farmers, loggers, sportsmen, and others work to restore their habitat. (Courtesy Gail Jenner.)

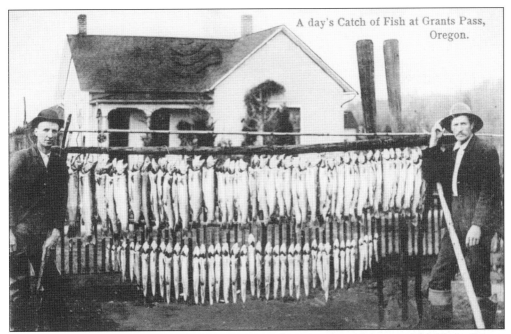

Fishing on the Rogue River near Grants Pass around 1920 was an adventure. The Upper Rogue was renowned for its quality salmon and steelhead fishing as well as for fly fishing, bank fishing, and drift-boat fishing. Even for its day, this had to be quite a catch. (Courtesy William and Rosalie More.)

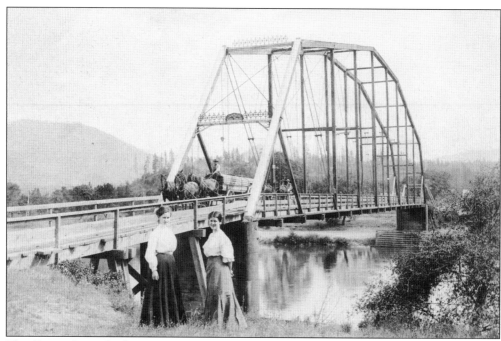

This Rogue River bridge, near Grants Pass, c. 1900, is typical of steel-truss bridges around Southern Oregon or Northern California. Many types of early bridges were often sold in "parts" that could then be assembled on site. (Courtesy William and Rosalie More.)

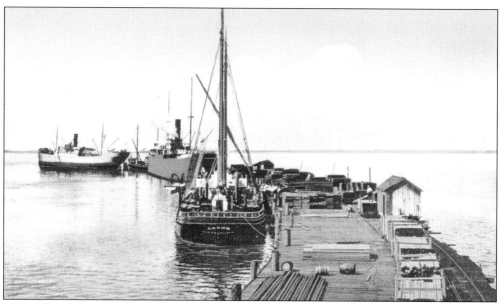

The gold rush brought Dr. Josiah Gregg and others overland along the Eel River to Humboldt Bay. Eureka and its neighbor Arcata (originally known as Union) were founded in 1850. Ships from San Francisco called on these Humboldt Bay ports, bringing people, mail, and supplies for the inland mining camps. Pack trains crossed the mountain trails leading from the bay to the interior. (Courtesy Gail Jenner.).

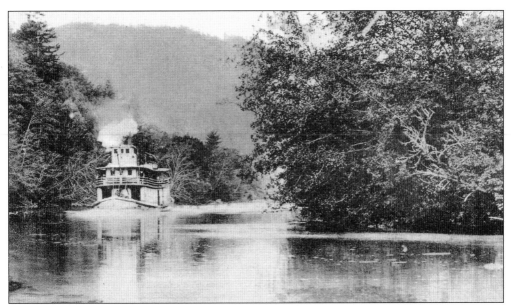

As Southern Oregon grew, so did its transportation system. Steam schooners, as well as locomotives, donkey engines, and mill equipment, all depended on cheap, plentiful coal. Packets and schooners carried passengers and freight north or south along the coast, while sternwheelers, like the *Despatch* on the Coquille River, transported people and supplies on most tributaries. In their wake, small settlements grew up around popular landings. (Courtesy Gail Jenner.)

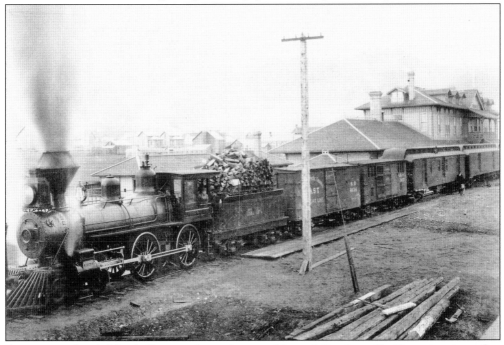

Arriving at the Ashland, Oregon, depot, is a southbound Southern Pacific train, soon after the Shasta Route through line was completed between Portland, Oregon, and San Francisco, California on December 17, 1887. Note the newly constructed hotel and the enormous stack of wood onboard the train. (Courtesy Nolan Printing.)

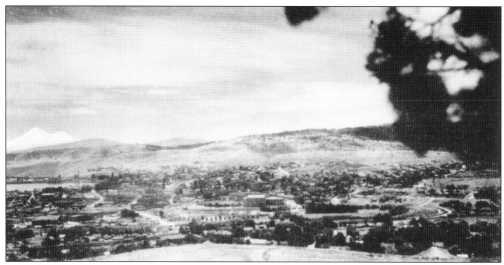

Klamath Falls, in Klamath County, Oregon, is located in a basin, which hugs the southern shore of the Upper Klamath Lake. It is 60 miles south of Crater Lake in south central Oregon, near the border of California. The area is home to thousands of wintering waterfowl and the largest population of bald eagles in the northern United States. It became an important stop in the railroad system that connected California and Oregon. (Courtesy Bernita Tickner.)

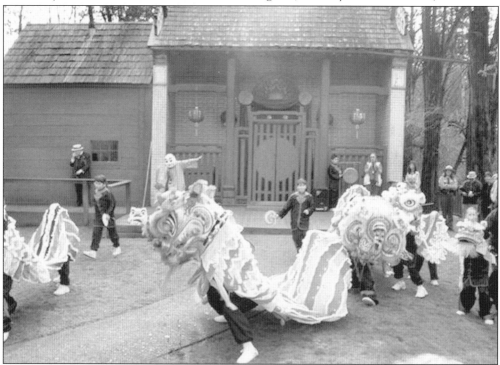

The Joss house, officially the Temple of the Forest Beneath the Clouds, is located in Weaverville on Highway 299, 50 miles west of Redding and 100 miles east of Eureka. It is the oldest continuously used Taoist temple in California and remains a place of worship. Built in 1874, it replaced another temple that burned. Here dancers perform a lion dance. In 1956, the temple became a part of the California State Park System. (Courtesy Greg Greenwood.)

Lassen Volcanic National Park is located in northeastern California, approximately 50 miles east of Redding. In 1914, Lassen Peak awoke. More than 100 smoking eruptions occurred within the next year, but the most significant activity took place in 1915, with minor activity through 1921. Lassen Volcanic Park became a national park in 1916 because of its significance as an active volcanic landscape. (Courtesy Bernita Tickner.)

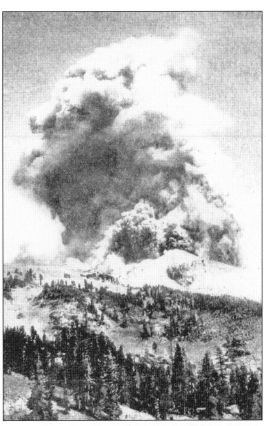

Theodore Roosevelt campaigned from the back of a train. Here he stops in Dunsmuir, California, in 1904. As president, he changed the nation's view about public lands and the national park system. From 1901 to 1909, he signed legislation establishing five national parks, including Crater Lake. He also set aside Tulelake National Refuge and Klamath National Forest. (Courtesy Siskiyou County Museum.)

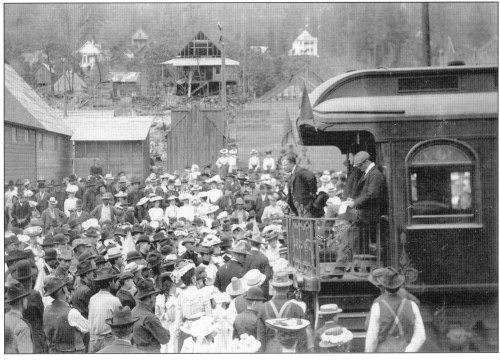

In front of Redding's "old" city hall, young men gather as they are inducted into the army to serve in World War I, c. 1917. On the right is George Diestelhorst, the son of one of Redding's earliest pioneer families. Descendants of the family still live and work in Redding. (Courtesy Dave Scott.)

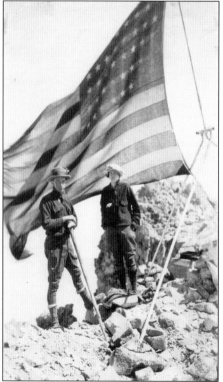

During the 1920s, Dorothy "Dot" DeNure Luce carried the American flag with a friend (unidentified) to the top of Mount Shasta after being challenged to make the treacherous climb. As stated by Clarence King, mountaineer, "There is no reason why anyone of sound wind and limb should not, after a little mountaineering practice be able to make the Shasta Climb." (Courtesy Joan Luce Akana.)

Three

JEFFERSON MOVES FORWARD IN TIME

The citizens of Northern California and Southern Oregon recognize the uniqueness of their areas.
They also realize that they have more in common with each other than either has with their state's
capitol. This, as well as the quality of life and the beauty of the environment, has led to a bond in the
minds of the area's inhabitants.

—James T. Rock, from *The State of Jefferson: The Dream Lives On!*

The State of Jefferson is unique not only because of its natural wonders, which are too numerous to reference completely, and not only because of its history, which is so rich 10 volumes would never do it justice. It is a place that, in some ways, feels suspended between past and present, rural and urban, wild and tame. People come here now for different reasons than those who came before, but it isn't long before they, too, are caught up by the unusual qualities of life here. In the minds of many old-timers, of course, newcomers can never appreciate this mythical place, but many find a home here. So the State of Jefferson builds upon its past and seeks to move in new directions. Farmers and ranchers hope to keep it open and untarnished; loggers and miners struggle against the odds that regulations have imposed; local tribes work to preserve what has been theirs; outdoorsmen come for the resources and beauty nature has endowed; and artists, artisans, musicians, et al, add to its diverse culture.

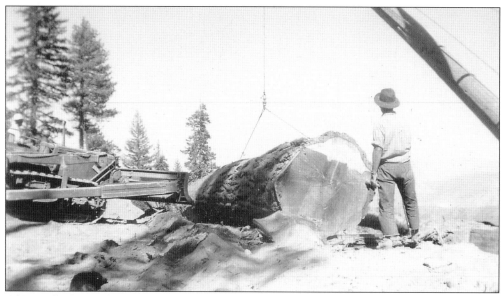

Al Burcell contemplates moving logs onto a landing at a mill near Etna, California. He worked for W. D. Miller Logging Company of Klamath Falls, Oregon. (Courtesy Mary V. Roff.)

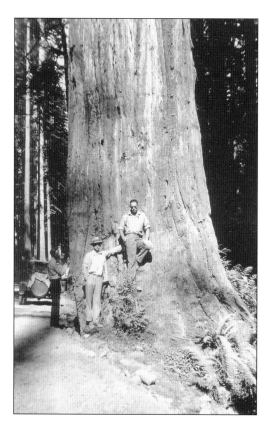

Enjoying the sights c. 1920s, three unidentified young men from Siskiyou County pose in front of a giant redwood while traveling to the coast. Note the vintage car on the dirt road. (Courtesy Desiree Kaae.)

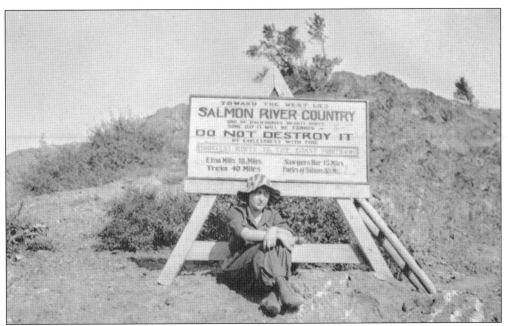

Seated at the top of Salmon Mountain *c.* 1920, Marie Piscantor (Jenner) of Fort Jones, California, rests near a roadsign sign: "Toward the West Lies Salmon River Country, One of California's Beauty Spots. Some Day It Will Be Famous . . . Shortest Route to the Coast Points. Etna Mills 10 miles; Yreka 40 miles; Sawyers Bar 15 miles; Forks of Salmon 32 miles." Of course, the mileage does not reflect the time it will take to travel the distance. (Courtesy John T. Jenner.)

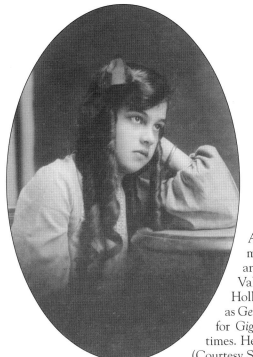

Anita Loos is one of the State of Jefferson's many notables. Born in Etna to R. Beers Loos and Minnie Smith Loos in 1888, she left Scott Valley as a child and eventually made her way into Hollywood's lineup of greats. She wrote such scripts as *Gentlemen Prefer Blondes* and coauthored the script for *Gigi*. She was uniquely driven, especially for the times. Her niece Mary Anita Loos also became a writer. (Courtesy Synthea and Vernon Smith.)

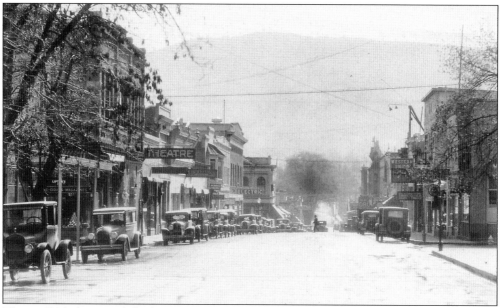

This *c.* 1926 photograph looks east on Miner Street in downtown Yreka. Note the theater and the electric company on the left and the Western Union office on the right. (Courtesy Dick and Ellen Janson.)

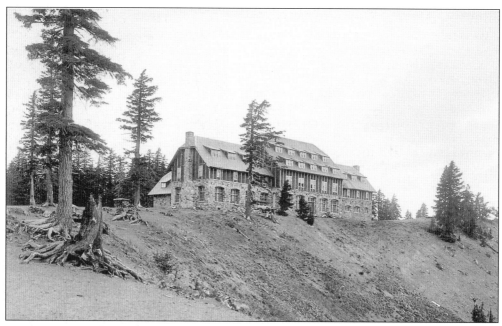

Opened to the public in 1915, Crater Lake Lodge was built by private investors to encourage tourism to Crater Lake National Park. Unfortunately it was situated in a barren and dusty setting and fell into disrepair. Both the park and the lodge were closed for a time during World War II. It was not until 1967 that the National Park Service acquired ownership of the lodge and began restoration. (Courtesy Bernita Tickner.)

From the Sacramento River near Red Bluff, a fisherman captures a 25-pound salmon, c. 1940. In its journey from the headwaters near Mount Shasta, down to the San Francisco Bay, the river flows through oak-studded hills. The river and its tributaries are rich in Native American history, with two sites—Bloody Island and Massacre Flat—testifying to the conflict that occurred between local tribes, miners, and settlers. (Courtesy Nolan Printing.)

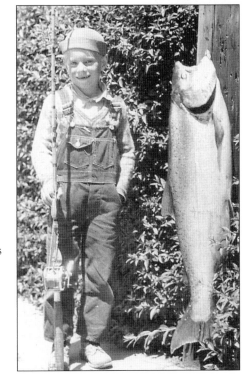

From the Rogue River, a young boy reels in a 49-pound salmon, c. 1940. The river's headwaters begin at Crater Lake then meander 215 miles through the Cascade, Siskiyou, and Coastal Ranges before reaching the Pacific Ocean at Gold Beach, Oregon. The Rogue is one of eight designated wild and scenic rivers, and though there are two major runs of salmon and steelhead annually, there are fish year-round. (Courtesy Nolan Printing.)

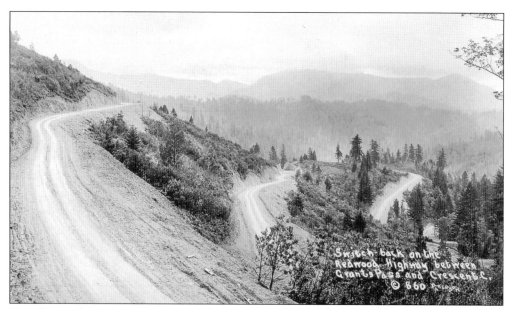

Traveling early roads was not easy. Here are several switchbacks on the Redwood Highway, between Grants Pass, Oregon, and Crescent City, California. On the way to the coast, motorists might stop at the Oregon Caves. The Redwood Coast Highway in California was designated a state highway by bond issue in 1909. By 1923, it was completed and opened to traffic in Del Norte and Humboldt Counties. (Courtesy Gail Jenner.)

Located downriver from Happy Camp, California, the Blue Nose Bridge that spanned the Klamath River provided the final link in the highway leading to Orleans in 1922 (Highway 96). Willits and Burr Company was given the contract to build the road to the Blue Nose Bridge. A Mr. Mosher was the road construction superintendent. (Courtesy Hazel Davis Gendron.)

Minerva Salisbury Starritt lived and taught at Morek School from 1929 to 1931. To travel the mountain roads often required riding a horse or mule over rough trails. Here Minerva's friend Mabel Harris, who worked as the school nurse on the Hoopa Reservation, stands in the middle of the dirt road that connects Hoopa and Weitchpec. These enterprising women drove the roads when they could and rode horseback when they could not. (Courtesy Ralph Starritt.)

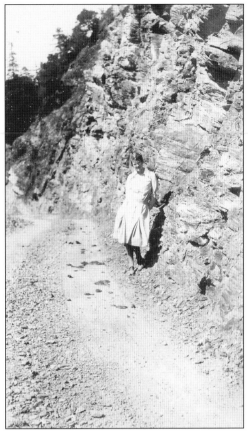

On one of their jaunts, Minerva Salisbury Starritt and Mabel Harris suffered a flat tire. Ambitious daredevils that they were, the young women repaired it and continued on. (Courtesy Ralph Starritt.)

Seen here building roads are, from left to right, Orin Lewis, Ralph Deppen, and V. W. "Dan" Roff. Before blasting, the men used jackhammers to widen the Blue Ridge road on Salmon River for the W. D. Miller Lumber Company of Klamath Falls, Oregon. (Courtesy Bernita Tickner.)

Doris Payne, author of *Captain Jack*, visits with Thomas Tickner at her home in Canyonville, Oregon. While many books have been written on the controversial events leading up to and following the Modoc War, in her book the author treats the Modoc Indians with compassion and credits Captain Jack, a man of circumstance, with humanitarian feelings. (Courtesy Bernita Tickner.)

Carl Barks was another early notable from the State of Jefferson. Born on a grain farm in Merrill, Oregon, in 1911, he was always busy drawing. He later found work with Walt Disney Studios and became famous for his cartoon characters, Donald Duck and Scrooge McDuck. Though he never signed his early works, fame followed quickly. (Courtesy Gail Jenner.)

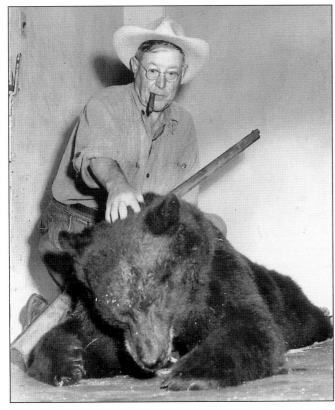

This large bear was shot and killed by Grandpa "Dick" Dudley, *c.* 1950s, in Noyes Valley, Siskiyou County, California. (Courtesy Melanie and Ken Fowle.)

Herbert Hoover was another well-known visitor to the region. A mining engineer and an avid outdoorsman, he owned a cabin on Wooley Creek and came frequently to fish. In addition, after visiting the Honolulu School on the Klamath River, he personally helped support a school lunch program until 1960. It has been said that his endeavor inspired the modern-day subsidized school lunch programs. (Courtesy Nolan Printing.)

Born Pearl Zane Grey in 1872, Zane Grey was a writer, adventurer, and sportsman. He became one of the first millionaire authors and spent part of the year traveling and the other part writing. His most famous book was *Riders of the Purple Sage* (1912). He built a cabin on an old mining claim that still stands along the Rogue River. (Courtesy William and Rosalie More.)

Here Romer Grey and and unknown person are shooting the rapids on Upper Black Bar Falls on the Rogue River. The top of Zane Grey's hat and his movie camera are barely visible in the lower left corner where he is filming the event. (Courtesy William and Rosalie More.)

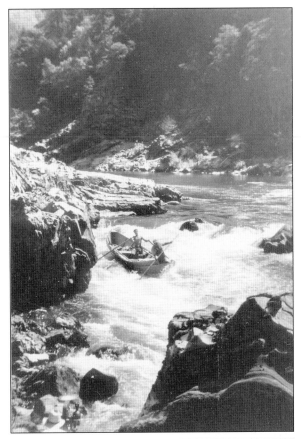

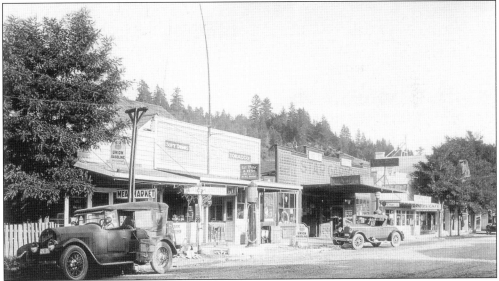

Garberville, located just a few miles north of Benbow Valley on Highway 101, is a rural community and serves as the gateway to the Avenue of the Giants (redwoods). The avenue runs parallel to Highway 101 for 30 miles and is bordered by Humboldt Redwoods State Park. (Courtesy Bernita Tickner.)

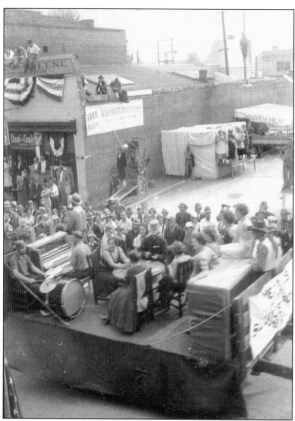

In 1932, a gold rush parade was held in Yreka, California, that wound its way down Miner and Fourth Streets. Note the float in the photograph. It represents an old-time saloon where soiled doves and gamblers enjoy the honky-tonk music. (Courtesy Dick and Ellen Janson.)

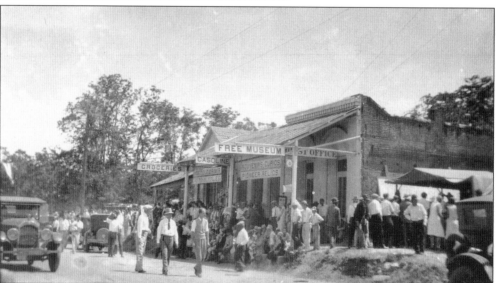

This June 1938 Pioneer Day celebration took place in Shasta, near Redding, California. Once the "Queen City," Shasta was a hub of activity from which material and men flowed to the northern mines and Southern Oregon. The town became famous for having the longest row of brick buildings, numbering more than 50. Shasta is now a state park. Note Litsch's Store, a landmark. (Courtesy Bernita Tickner.)

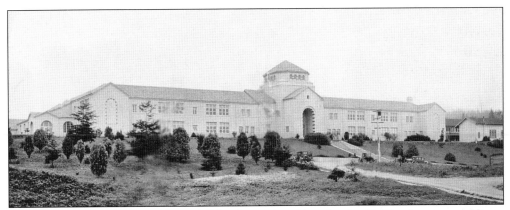

In 1913, the Humboldt State Normal School was signed into law by California governor Hiram Johnson. Eureka, Arcata, and Fortuna competed for the right to host the school, and Arcata citizens won, led by William Preston who donated a 12½-acre site. In 1916, 15 students graduated in the first commencement. In 1921, the name changed to Humboldt State Teachers College. This photograph shows the school around 1930. (Courtesy Bernita Tickner.)

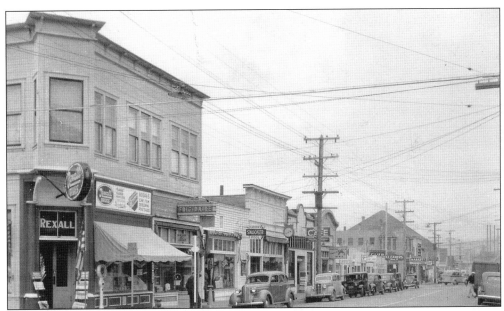

The town of Crescent City, California, dates back to 1852, when treasure hunters discovered the harbor while searching for the "Lost Cabin Mine." Tidal waves, or tsunamis, have hit the Pacific coastline. One story, told by the Tolowa tribe, speaks of a tidal wave that hit the Crescent City coastline sometime between 500 to 1,000 years ago and destroyed almost everything and everyone in the village. In 1960, a tsunami again hit Crescent City, killing several people and damaging many buildings in the coastal area. (Courtesy Gail Jenner.)

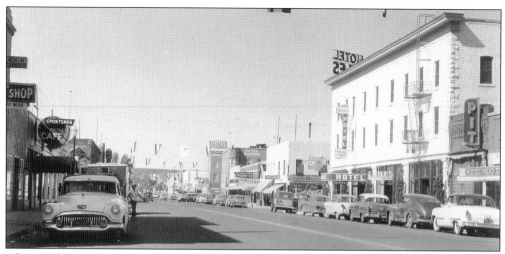

Alturas, the seat of Modoc County, lies in the valley of the Pit River, near the center of the county. The valley is actually a prehistoric lake bed. Alturas, which in Spanish means "valley on top of a mountain," was originally occupied by a branch of the Pit River or Achomawe tribe. To the south is the Modoc National Wildlife Refuge. (Courtesy Bernita Tickner.)

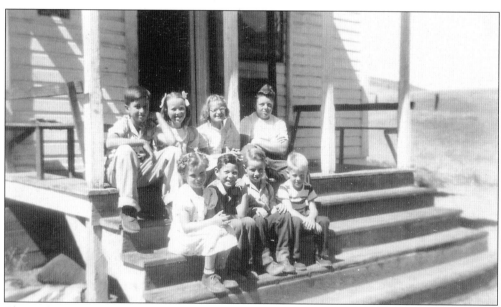

This is the Willow Creek Grammar School in 1948, located in Siskiyou County. There are still many one-room schoolhouses in the region. Seated on the steps, from left to right, are (first row) Barbara Betts Lee, Daryl Severns, Spike Hoag, and Mike Hume; (second row) Jerry Hagedorn, Karen Severns Currie, unidentified, and Denny Hume. (Courtesy June Severns.)

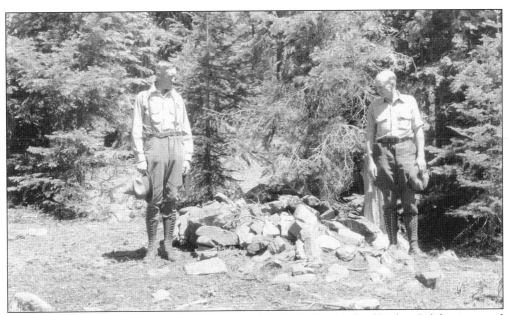

John D. Campbell, left, of Etna, California, and Leslie J. Campbell of Yreka, California, stand over the grave of three pioneer freight wagon drivers who were murdered by Modoc Indians in 1873. Their father was the lone survivor of the attack. The location is noted as Garvey Glade on Ball Mountain. The photograph was taken on July 2, 1939. (Courtesy Nolan Printing.)

The West Branch U.S. Forest Service Guard Station, Happy Camp District, located on the west branch of Indian Creek, is seen here under construction by the Civilian Conservation Corps (CCC) from Indian Creek Camp F21, c. 1933. Lawrence Roberts was the foreman. In 1933, six CCC camps were constructed in the Klamath National Forest. (Courtesy Hazel Davis Gendron.)

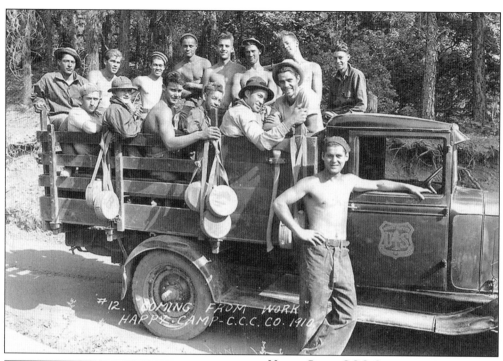

Happy Camp CCC Company 1910 is "returning home from work." Note the United States Forest Service (USFS) truck and canteens. This was one of the first crews in the Indian Creek/Clear Creek area. The truck is a 1932 Ford. The foreman was Hazel Davis Gendron's father, Lawrence Roberts. These CCC crews built campgrounds and roads and fought fires all over this area from 1933 to World War II. (Courtesy Hazel Davis Gendron.)

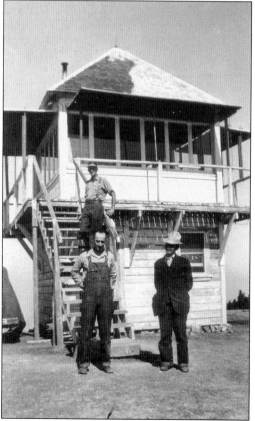

This is the Baldy Mountain lookout with Herb Cook, Lawrence Roberts, and Dave Robinson. Built on a flat mountaintop, it had to be elevated to watch Indian Creek drainage, Klamath River, and Happy Camp. Another famous lookout "ranger" was Hallie Daggett, 30-year-old daughter of John Daggett, who was the first woman lookout in the USFS. She served 13 years, beginning in 1913, atop Eddy Gulch Lookout Station on Klamath Peak. (Courtesy Hazel Davis Gendron.)

Port Orford Lifeboat Station Museum (Coast Guard Station No. 318) was constructed in 1934 by the U.S. Coast Guard to provide lifesaving service to the southern portion of the Oregon Coast, a service performed until 1970. The crew quarters and offices are now operated as a museum and interpretive center. (Courtesy Rick Francona.)

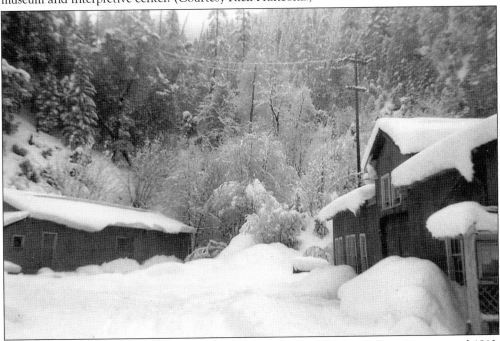

The Grey (or Gray) Eagle Copper and Gold Mine was discovered by Judge Brown around 1910, but developed by Dakin, who discovered a large body of copper ore. He sold the Grey Eagle in 1916, but work stopped after World War I and did not resume until World War II. The mine shipped 465,000 tons of copper ore concentrates by tramway to Thompson Creek, hauled it to the Montague and Hornbrook train depots, to be sent on to Tacoma, Washington. The mine brought electricity to Klamath River and Happy Camp. (Courtesy Arlene Titus.)

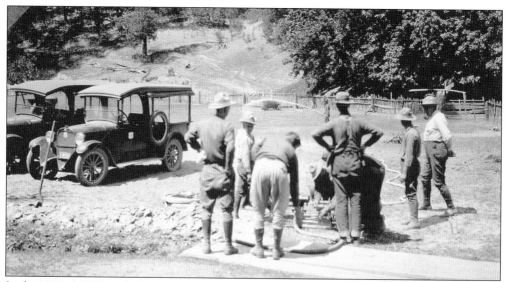

In the 1930s, USFS firefighters survey trucks and equipment and go through trial demonstrations. The forest service, first called the Forest Reserves, was created to help sustain and promote productive forests and grasslands. One of the first improvements made by the forest service was the introduction of telephone lines into remote, forested areas. The location and subjects of this photograph are unidentified. (Courtesy Siskiyou County Museum and USFS.)

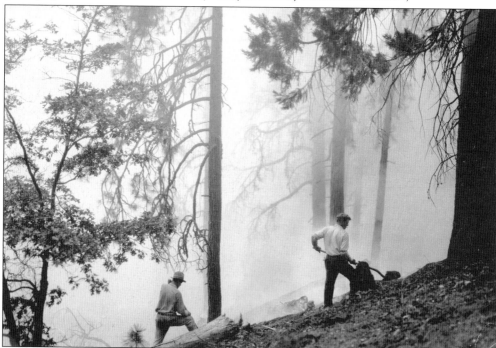

Wildfire has the potential to affect landscape more than volcanoes, earthquakes, or floods. However, many plants and animals cannot survive without the cycles of fire. Today the USFS and National Park Service stress managing fire, not merely suppressing it. They support the use of fire as a management tool. This is the 1927 Soap Creek fire, not a prescribed burn. (Courtesy Siskiyou County Museum and USFS.)

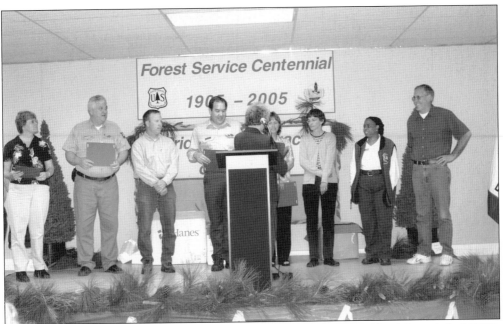

On July 1, 2005, the United States Department of Agriculture (USDA) celebrated the USFS's 100th anniversary. Pictured on stage, from left to right, are Linda Karns, Allen Tanner, Dave Webster, Brian Thomas, Julie Perrochet, Karen West, Regina McFall, and Rick Svilich. At the podium is Peg Boland, forest supervisor. (Courtesy Mike Lee, Judy McHugh, Regina McFall, USFS.)

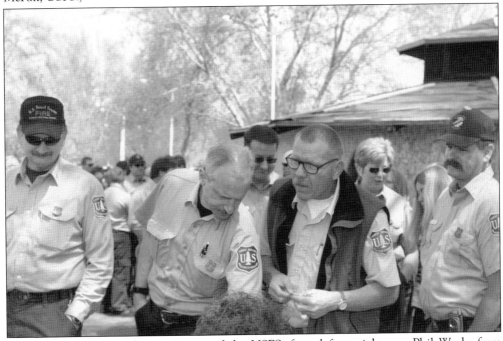

Celebrating at the 100th anniversary of the USFS, from left to right, are Phil Weeks from Happy Camp; Jim Constantino from Goosenest; Ralph Schurwanz, dispatch; and Jim Allen from Salmon River. (Courtesy Mike Lee, Judy McHugh, Regina McFall, USFS.)

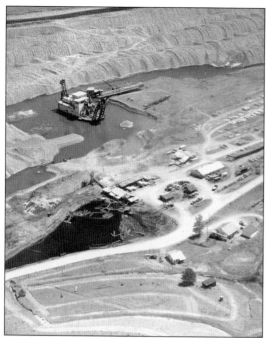

The W. H. Munson Lumber Company sawmill was located between Etna and Callahan. Powered by a diesel motor, the mill produced about 25,000 board feet of lumber daily and employed 12 to 15 men at $1.25 to $1.50 per hour. In 1959, it ceased operation. In the background is the Yuba Consolidated Dredge that operated during the 1930s, shutdown during World War II, then resumed production until 1952. This aerial photograph was taken in 1953. (Courtesy Willie Munson.)

A native of Norway, E. J. Hjertager and Son built a sawmill in the 1940s in Scott Valley, California, at the mouth of Wildcat Gulch. Before that, Hjertager owned a sawmill on the opposite side of Scott River near Callahan. Bill Watrous recalls that 20 to 25 men were employed to saw an average of 60,000 board feet per day. A few employees included Delmar Botts, Bill Cowdry, Stanley Moore, Albert Facey, Hugh Webster, and Kenny Moak. (Courtesy Nolan Printing.)

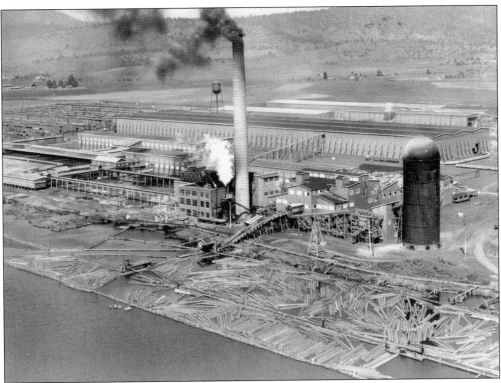

Around 1939, Weyerhaeuser at Klamath Falls, Oregon, employed over 1,000 men and produced almost 200 million board feet of wood product each year. At the start of World War II, the company experienced a surge in production as companies shifted to wartime manufacturing of airplane crates and ammunition boxes. In 1905, the Weyerhaeuser Company had purchased the Klamath Lake Railroad and regional forestlands. By 1908, the company owned more than 158,000 acres. (Courtesy Nolan Printing.)

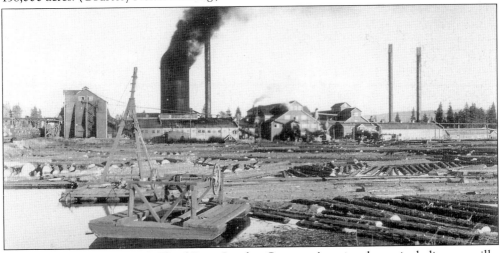

Shown here in the 1900s, McCloud River Lumber Company's entire plant—including sawmills, planing mills, factories, dry kilns, lumber sheds, etc.—covered over 700 acres, according to their advertising. Its shed capacity was 15 million board feet and its yard capacity was 65 million board feet. (Courtesy Gail Jenner.)

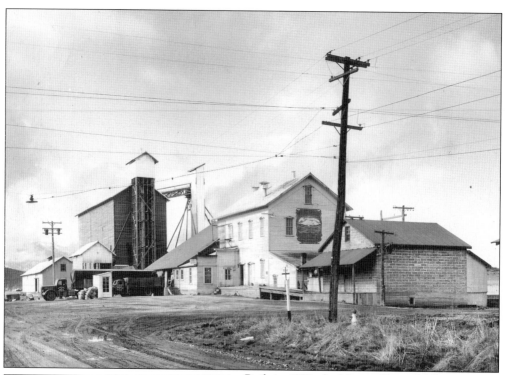

Built in 1893, the Mount Shasta Milling Company was located in Montague, California. In 1898, it installed a 100-kilowatt hydroelectric plant on Little Shasta River east of Montague and transmitted energy about nine miles to the flour mill. Some light service was also furnished to other customers in town. The mill operated until 1958. (Courtesy Nolan Printing.)

On the East Fork of Salmon River, Francis George is busy forking hay into shocks to dry. Afterwards he pitched the hay onto a horse-drawn wagon to haul to the barn. Most of the haying he did alone. One time, George, in his sixties, cut all of his hayfields alone with only a hand scythe—about 20 acres. (Courtesy Bernita and Thomas Tickner.)

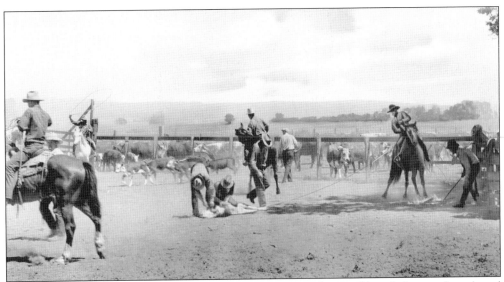

A roundup takes place in Modoc County around 1939. Ranchers and hands frequently gathered to round up cows and calves so that calves could be "marked" and branded. Here the men work together to rope the calf. Note that there has been some retouching to the horse at right in this original photograph. (Courtesy Nolan Printing.)

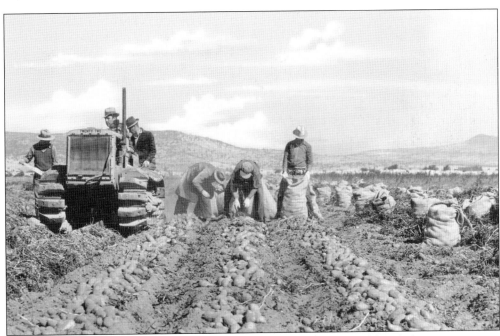

Pictured here in Klamath County near Tulelake, farmers and hired hands harvest potatoes. This region quickly became noted for its potatoes and horseradish. Hired help often traveled from one place to another, following the various harvests. (Courtesy Nolan Printing.)

Orchards thrive in Southern Oregon. Pears and other fruit have been raised commercially for many years and now vineyards are being planted, although Peter Britt has been credited with planting some of the first vineyards in the region. An old, popular song boasted about Oregon: "There'll be apples on each branch in Oregon; there'll be valleys filled with golden grain. There'll be cattle on each ranch in Oregon; and there'll be plenty of sun and rain." (Courtesy Bernita Tickner.)

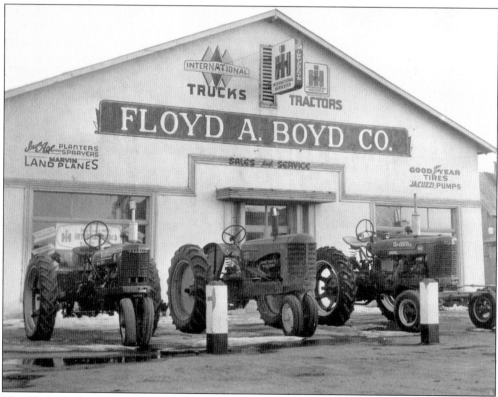

The Floyd A. Boyd Company in Tulelake is shown here in the 1940s or 1950s. Floyd A. Boyd also owned a business in Yreka. The company has been serving the region since 1940. (Courtesy Nolan Printing.)

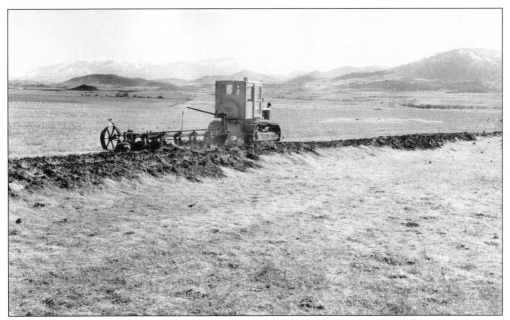

On a brisk March afternoon in 1953, on the Clement brothers' ranch northeast of Yreka, a Caterpillar Diesel D-4 tractor pulls an Oliver disk plow. Note the snowcapped peaks in the background. (Courtesy Nolan Printing.)

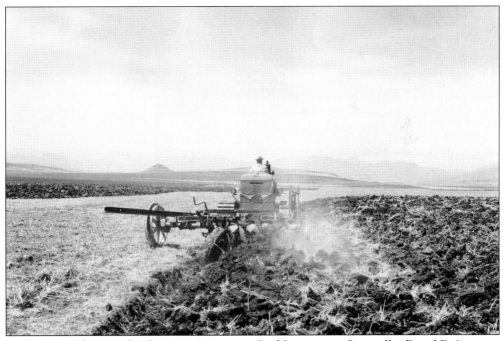

In this 1950s photograph taken near Montague, Paul Logan, in a Caterpillar Diesel D-6 tractor, pulls a John Deere disk plow across wheat stubble. For many years, Montague has been a center of agricultural development. (Courtesy Nolan Printing.)

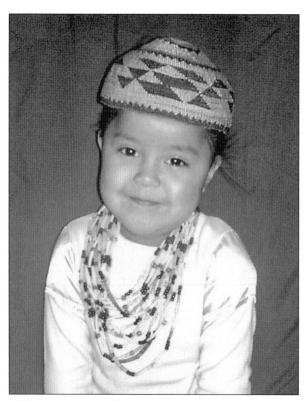

Three-year-old dancer AliyseCiana Dominguez-Aguilar, in traditional dress with a basket hat, waits to join in the Karuk ceremonial dances. (Courtesy Kayla Super.)

Dressed in traditional regalia as they wait to dance in the Karuk Brush Dance, pictured from left to right are Marques Super, Trevor Super, and David Super. (Courtesy Kayla Super.)

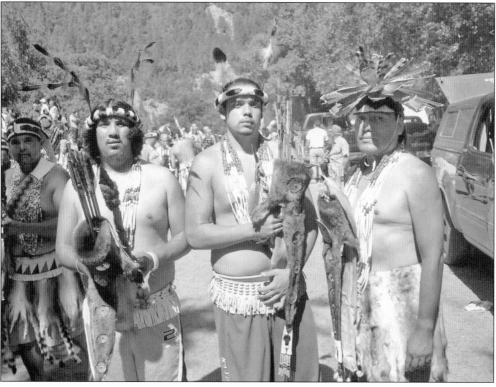

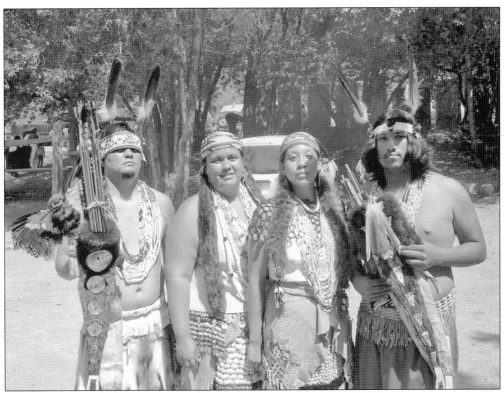

Young Karuk Brush dancers prepare for a performance. Pictured, from left to right are Conrad Croy, Kayla Super, Shereena Baker, and Marques Super. (Courtesy Kayla Super.)

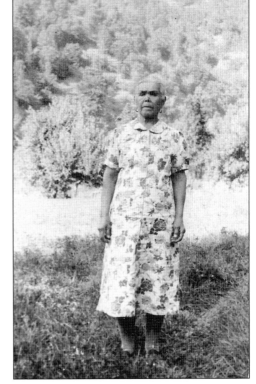

Grandma Kate Duzel Martin, pictured in 1940 at approximately 75 years old, was the wife of Tom Martin of Hamburg, California. Duzel Rock, a landmark, was named for her father, George Adolphous Duzel, who is believed to have come to Scott Valley with the early fur trappers. Doc Ginny, a native herb doctor, was Kate's mother. Tom Martin Peak was named for her husband. (Courtesy Hazel Davis Gendron and Hank Mosotovoy.)

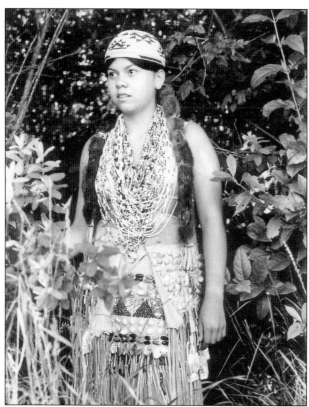

Shirley King is the daughter of Aaron and Barbara Davis King and granddaughter of Francis and Grace Davis from down the Klamath River. Here she is pictured in traditional Karuk dress. (Courtesy Hazel Davis Gendron.)

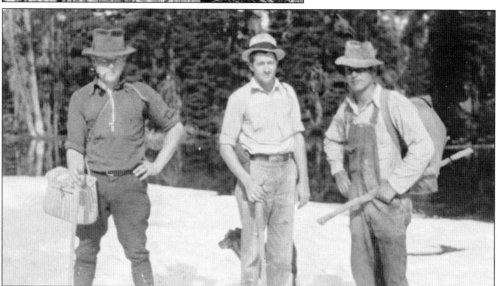

From left to right are Otis Bottoms, Russell Farrington, and Abe Colt on an ice-fishing adventure at Boulder Lake, outside Callahan, California, c. 1938. Farrington later recalled that Abe suddenly crashed through the ice and it was several long minutes before he surfaced again. These mountain lakes were routinely stocked with fish that had to be packed in on mules. Curtis "Tuffy" Fowler, his father, and partner John Ahlgren packed in tins of fry for many years. (Courtesy GloryAnn Jenner.)

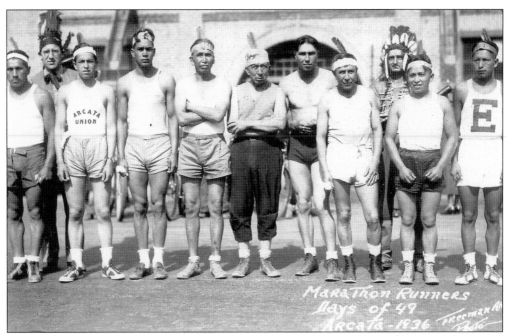

The 1936 Redwood Marathon race celebrated "Days of '49." In the middle, with dark hair, is Harold Blake. To his left is Harry Chester (older man). On the far right is Paul Moon. The others are unidentified. (Courtesy June Severns.)

When the call for chrome came during World War I and World War II, Siskiyou County started digging. Alonzo Bingham remembered that some tested as high-grade chromium. Without bulldozers, chrome ore was transported by pack animals or horse-drawn sleds to a place where it could be loaded onto wagons and hauled to railheads. Some miners and packers included Curtis "Tuffy" Fowler, Joe Richter, Ernest Hayden, John McBroom, his son John Nelson McBroom, Francis George, Virgil Gray, Dorothea Maroni (known as the "Chrome Queen"), and Mrs. Molloy (a truck driver). In this photograph taken during World War I, V. W. "Dan" Roff packs chrome from Crow Creek near Castella, California. (Courtesy Bernita Tickner.)

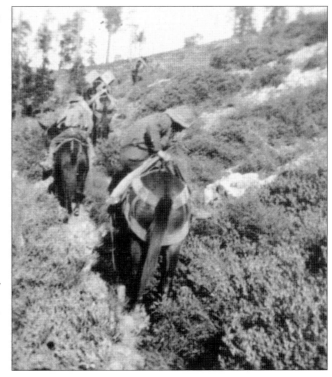

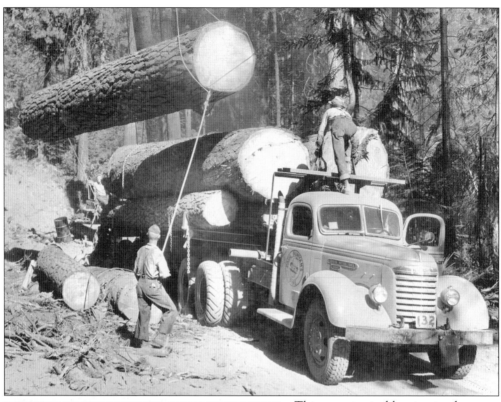

This was a typical logging truck, pictured being loaded during the 1950s. The truck reads, "Paul Bunyan's Pine." Note the winches, cables, and ropes, but no hard hats. The exact location is not known. (Courtesy Nolan Printing.)

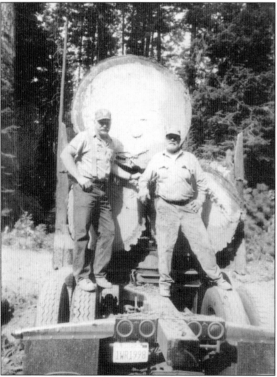

Gary Tickner and Ed Stone pose in front of a 5-foot by 32-foot sugar pine log from Dutch Creek on the California-Oregon border. Tickner estimated that the whole load probably yielded 7,800 board feet. Dutch Creek is a tributary of Applegate Creek, and most of the logs in the area were comparable in size. (Courtesy Bernita Tickner.)

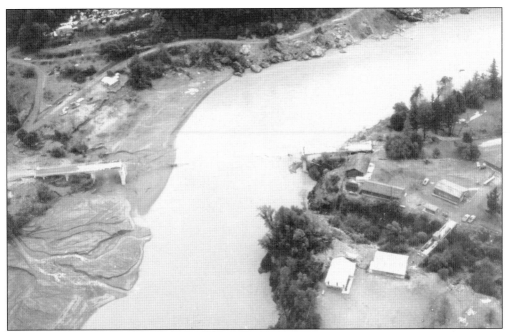

The "newest" Orleans Bridge was destroyed by the 1964 flood. The first was constructed in 1912, but was destroyed by fire in 1921. Twenty firefighters fought the blaze by lowering buckets into the Klamath River. Standing on the bridge when the cables snapped, the men were dumped into the river and one was killed. Canoes were used until a new bridge was built. The historic suspension bridge lost here was the last of its type to be built in the United States. (Courtesy Hazel Davis Gendron.)

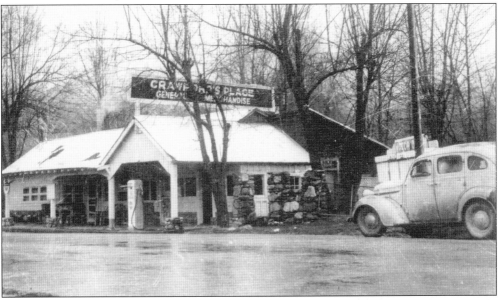

Though the 1964 flood was nearly catastrophic for those in Northern California and Southern Oregon, floods have occurred on a regular basis. Crawford's Place, owned and operated by Cyrus and Bessie Crawford from the late 1930s until 1940, was swamped in the 1940 flood. Later Cyrus Crawford was killed while working at Finley Logging Camp. (Courtesy Hazel Davis Gendron.)

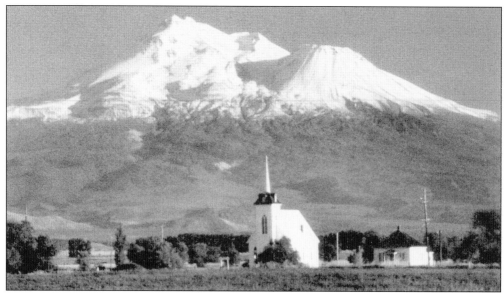

The Little Shasta Church was built in 1878, paid for by subscriptions. Fund-raising for renovation began in 1998, with the sale of bricks, and remodeling was completed by June 1999. Pat Martin and others in Little Shasta were instrumental in raising the money for the work. Open to the public, the church is a frequent setting for weddings. (Courtesy Erich Ziller.)

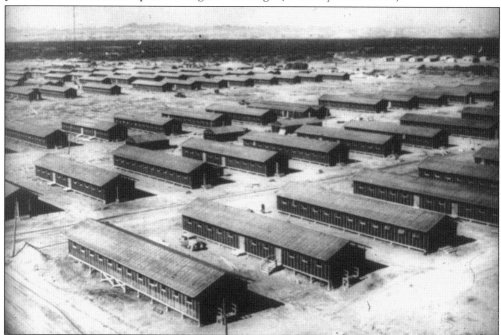

On February 19, 1942, Pres. Franklin Roosevelt signed Executive Order 9066, which led to the internment of 120,000 Japanese Americans. Two-thirds of these people were American citizens, but in the heat of war, they were stripped of their personal possessions as well as their constitutional protections. Pictured here are the housing barracks that were part of the Tulelake relocation site at Newell, California. (Courtesy Tulelake Museum and Siskiyou County Museum.)

Stella Walthall Patterson wrote about the adventures of a woman who, at age 80, found a new life in the Klamath Mountains near Happy Camp, California. Stella passed away in 1955, so she never witnessed her book's final, unabridged publication. Here Stella and Jim Patterson are sitting on Frank and Nellie Ladd's porch at Old Denny, California, c. 1907. Stella wrote for *Century Magazine* and *Collier's*, among others. (Courtesy Gay Berrien.)

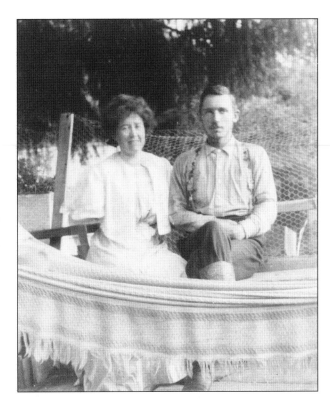

Ralph Cummins, a Western pulp writer, had a beautiful home in Los Angeles but preferred to live on the North Fork of Salmon River. In his eighties, he became ill and returned to Los Angeles where he passed away. Ralph spent most of his life in the West, where he prospected, cut logs, sawed lumber, punched cows, shocked hay, drove stage, fought fires, rode brake beams, made motion pictures, fished trout, and wrote stories. His novel *Sky-High Corral* was made into a film. (Courtesy Bernita Tickner.)

Lauren Paine, freelance writer and author, lived in Fort Jones, California, for many years and has been titled the most prolific writer to ever have lived. He wrote more than 900 western titles under an assortment of pseudonyms. In 2003, one of his stories, *Open Range*, was made into a popular movie starring Kevin Costner and Robert Duvall. (Courtesy Daniel Webster and the *Pioneer Press*.)

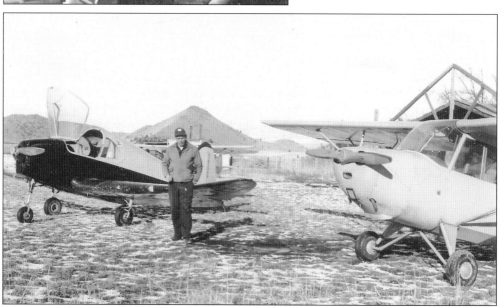

Weed Airport, located near Edgewood on Interstate 5, is one of five airports maintained and operated by Siskiyou County. At an elevation of 2,938 feet, it has 15 individual hangars and 34 tie-down spots on its paved surface. This photograph was taken in the 1940s or 1950s. (Courtesy Nolan Printing.)

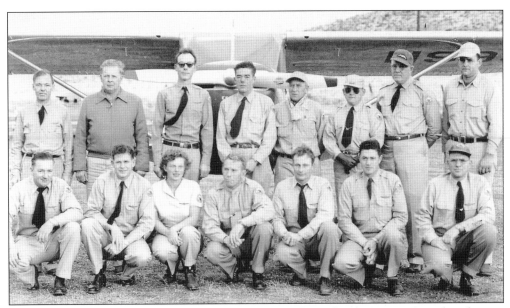

The Aerial Sheriff's Squadron was formed in the 1950s and completed a variety of search and rescue missions for downed planes or lost hikers. Pictured, from left to right, are (first row) F. Greathouse, Yreka; Mr. and Mrs. G. McFarland, Montague; L. Purinton, Yreka; D. Coonrod, Montague; B. Davis, Fort Jones; and J. Wilmarth, Weed; (second row) Dr. Clough, Etna; E. Hjertager, Callahan; C. Seaver, Etna; William Scammell, Montague; L. D. Nichols, Dunsmuir; Jim Culley, Weed; H. Struthers, Weed; and George Wright, Mount Shasta. (Courtesy Nolan Printing.)

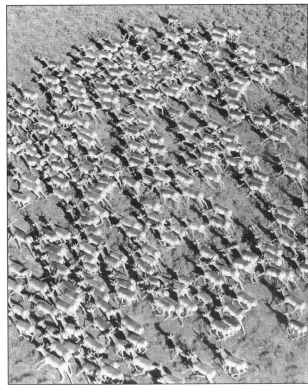

Antelope, seen here in Lake County, run in large herds. The Hart Mountain Antelope Refuge protects one of the nation's largest herds of pronghorn antelope. Hart Mountain has an elevation of 8,065 feet. (Courtesy Nolan Printing.)

A popular tourist stop, the Trees of Mystery features some of the oldest and tallest coastal redwoods, some dating back 2,000 years. A six-passenger gondola takes visitors across the park to view the giant trees from the forest canopy. The park is located at Klamath, 40 miles south of the Oregon border and 16 miles south of Crescent City, on Highway 101. Paul Bunyan greets visitors. (Courtesy Gail Jenner.)

Before the Klamath River Bridge on the Redwood Highway was completed in 1965, two sections of U.S. Highway 101 had to be relocated. South of the Klamath, the road had to negotiate Waukell Creek, while north of the Klamath, one-half mile of roadway had to be realigned so that it would meet the approach to the new bridge. (Courtesy Gail Jenner.)

The Shasta Bridge, shown here, is a beautiful arched bridge and the next after crossing the Pioneer Bridge on Highway 263. The Pioneer Bridge, dedicated in 1931, spans the Shasta River, seven miles north of Yreka. It is 794 feet long and 252 feet above the water. (The Golden Gate Bridge is 220 feet above the water.) A favorite sport not only for youngsters has been trying to throw a rock into the Shasta River from the parking area at the north end of the steel bridge. Several skilled baseball pitchers have tried but failed. (Courtesy Nolan Printing.)

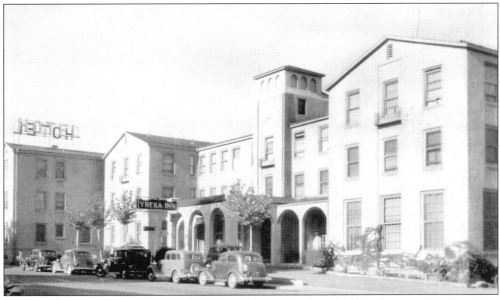

In 1923, when L. L. Weaver proposed building the grandest hotel halfway between San Francisco and Portland, local businessmen helped him, and in 1925, the Yreka Inn opened for business. It became popular, not only with tourists, but also with locals. Unfortunately the hotel was torn down in 1975. It could not compete with the lower-cost motels being built up and down the highway. (Courtesy Nolan Printing.)

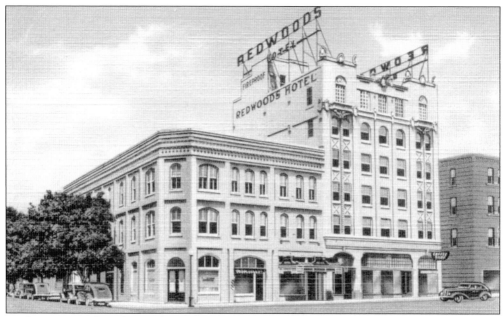

In the 1930s, Redwoods Hotel in Grants Pass was considered one of Southern Oregon's finest hotels. It featured dining rooms and a coffee shop and was positioned at the junction of the Pacific and Redwood Highways. (Courtesy Gail Jenner.)

Richard Silva and two members of the Oregon-California Trails Association (OCTA) walk a remnant of the Siskiyou Pioneer Wagon Road. Silva is a trails expert and historian whose research has proven invaluable to many searching family roots and local history. (Courtesy Siskiyou County Museum.)

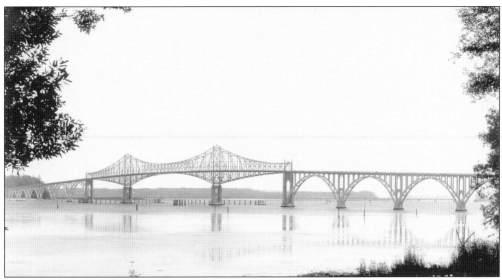

The Coos Bay Bridge was one of a series of six bridges built along the Oregon Coast Highway. Built in 1936, it was dedicated in 1947 in honor of its designer, Conde B. McCullough, after his death. At the time, this cantilever-truss bridge was the longest of its kind and measured 5,305 feet. (Courtesy Gail Jenner.)

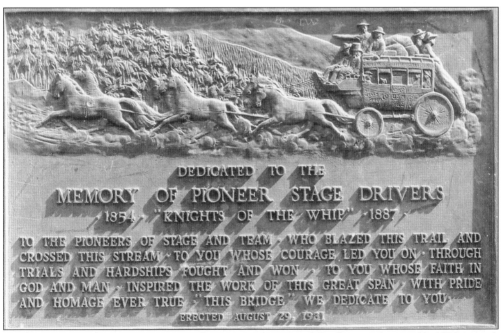

A plaque, erected to commemorate the Pioneer Memorial Bridge on August 29, 1931, stated, "1854 Knights of the Whip 1887: To the pioneers of stage and team/ who blazed this trail and crossed this stream/ to you whose courage led you on through trials and hardships fought and won/ to you whose faith in God and man/ inspired the work of this great span/ with pride and homage ever true/ "This bridge" we dedicate to you." (Courtesy Gil Davies, Florice Frank and W. J. "Mac" McKellar.)

Positioned on highways throughout the nation, Blue Star Memorial Markers pay tribute to veterans. The idea originated after World War II with the New Jersey Garden Club. All markers read, "A tribute to the Armed Forces that have defended the United States of America." In Siskiyou County, there are markers on Highway 97 at the Grass Lake Rest Stop, on Highway 89 near McCloud, and at Collier Rest Stop, Interstate 5. (Courtesy Gil Davies, Florice Frank and W. J. "Mac" McKellar.)

Hilt was named for John Hilt of O'Fallon, Illinois. He arrived in 1852, but in 1877, he bought a sawmill two miles west of Hilt, which he operated until 1890. Four men purchased it and founded Hilt Sugar Pine Company. They also founded the town, naming it after John. In 1906, the company was sold to Northern California Lumber Company, who went bankrupt. Fruit Growers Supply assumed control of the logging operations and sawmill. (Courtesy Bernita Tickner.)

It's a winter day in 1992 at Carter Meadows Divide on the Callahan-Cecilville road. Enjoying the snow are Trevor and Levi Tickner. This historic route was traveled by mules and horses, and is still subject to closures in wintertime. (Courtesy Bernita Tickner.)

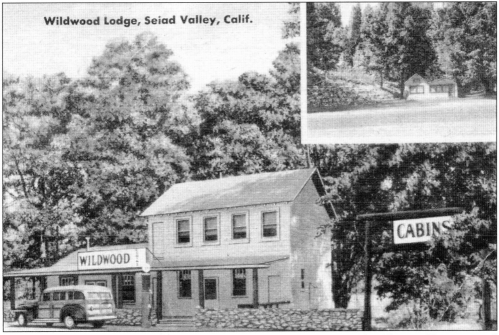

The Wildwood Lodge in Seiad Valley, California, started as a one-story building and bar, operated by Al and Betty Ferry. It was later sold and remodeled with a two-story addition by George and Mary Hubbard. Over the past years, the 24-foot bar and interior have been beautifully preserved by various owners. (Courtesy Hazel Davis Gendron.)

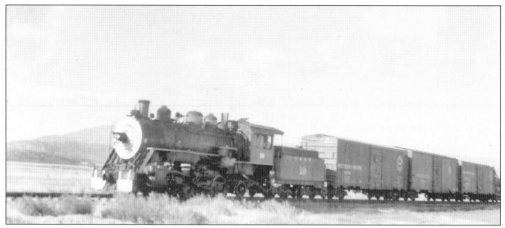

Yreka Railroad opened for business in 1889, but traffic at first was slow. Engine No. 19, a smaller Baldwin 2-8-2, was built in 1915, but was not purchased by the McCloud River Railroad until 1924, after serving time in Mexico. McCloud workers nicknamed No. 19 "Pancho," for the famed Mexican revolutionary Pancho Villa, after discovering several bullet holes while working on it. It was later purchased by the Yreka Western Railroad. (Courtesy Nolan Printing.)

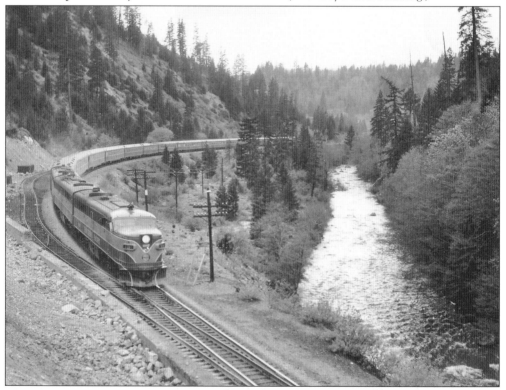

The Shasta Daylight was titled "the million dollar train with the million dollar view" and boasted, "You leave in the morning, arrive that night." The train linked Portland, Oregon, and San Francisco, California. Three California Daylights already joined San Francisco to Los Angeles. The Shasta Daylight provided a fast and luxurious ride as well as spectacular scenery, all in daylight. It made stops in Redding, Dunsmuir, and Klamath Falls. (Courtesy Bernita Tickner.)

Copco Dam No. 1, northeast of Yreka, California, was completed in 1918, followed by Copco No. 2 in 1925. The dams, built on the upper Klamath River, have become the center of controversy in the last few years, as the issue over water rights continues to grow. Ropes are used to assist the surfacing divers, who remove trash from screens and check the dams for faults. (Courtesy Siskiyou County Museum.)

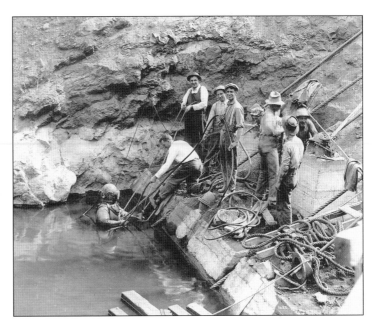

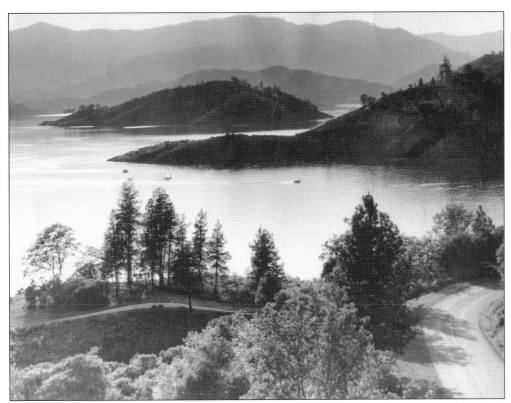

Lake Shasta provides water for irrigation, power, and recreation. Its shoreline stretches 365 miles. Houseboats and ski boats, along with fishing boats and swimmers, find the expansive lake an attractive vacation site. Campgrounds and RV parks are growing in popularity. (Courtesy Nolan Printing.)

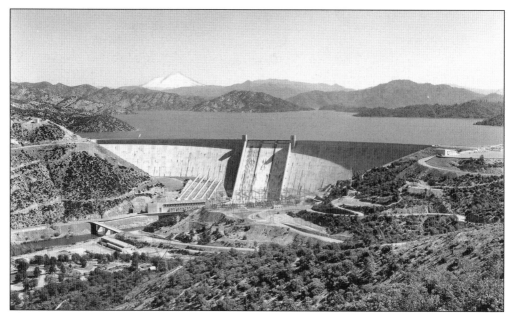

Shasta Dam was begun in 1938 and completed in 1944. It holds back enough water to cover the entire state of Connecticut, and its spillway is three times higher than that for Niagara Falls. (Courtesy Nolan Printing.)

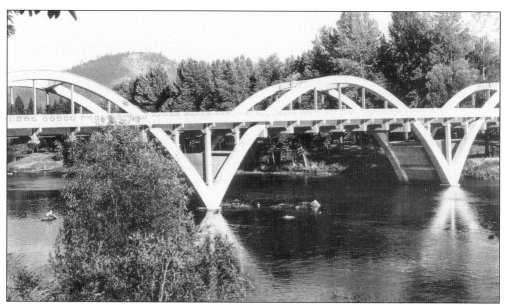

A ferry opened in 1884 where Caveman Bridge is today. In 1885, Grants Pass, Oregon, was incorporated and the county borders adjusted, placing the city in Josephine County. In 1883, the Southern Pacific Railroad arrived and Grants Pass grew. In 1886, the first bridge was built across the Rogue River at Grants Pass. The Caveman Bridge crosses the Wild and Scenic River on Sixth Street and is listed on the National Register of Historic Places. (Courtesy Gail Jenner.)

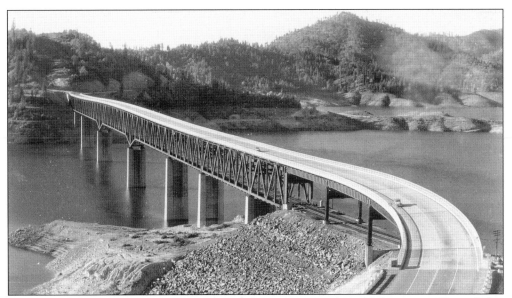

From Redding, Interstate 5 cuts north over to the Pit River Bridge and then across Shasta Lake. With its many arms, bays, and extensive shoreline, the lake seems more like several lakes rather than one. Bridge Bay Resort is located on the Pit River Arm near the bridge, and the Silverthorn Resort is located on the Pit River Arm in the Jones Valley area. The bridge was dedicated to Veterans of Foreign Wars. (Courtesy Nolan Printing.)

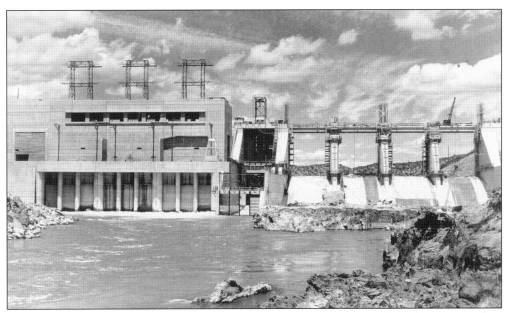

Keswick Dam, south of Shasta Dam, was named for Lord Keswick of London, who was president of the Iron Mountain Copper Company, Ltd. Work on Keswick Dam began August 18, 1941, and was completed in 1950. With the intervening war, work slowed and problems occurred, including a strike in 1942. When the strike was over, the workers received an increase in pay of 20¢ an hour. (Courtesy Nolan Printing.)

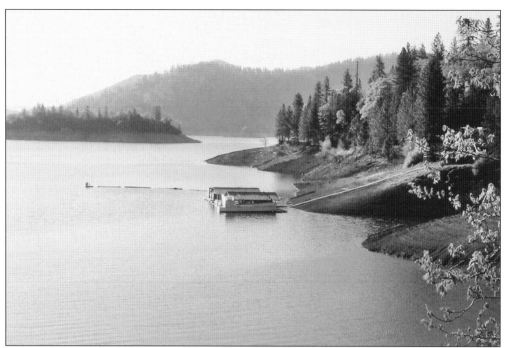

Trinity Lake covers some 16,000 acres and is the third largest lake in California, with approximately 147 miles of shoreline, most of it timbered and undeveloped. Clair Engle Lake, behind Trinity Dam, stores water from the Trinity River for release through the Trinity Power plant. Fed by the Trinity River, the crystal-clear water is cool. Generally not crowded, it is a favorite place for locals. (Courtesy Nolan Printing.)

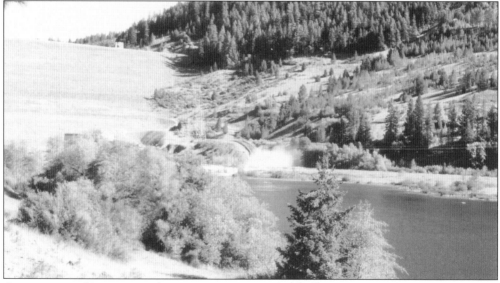

Construction of Trinity Dam began in 1956, when Allum Brothers of Eugene, Oregon, received the contract for excavation of the outlet tunnel. Trinity Dam's embankment consists of four types of raw materials, including an impervious core material, a semi-impervious layer on either side of the core, river gravel, and rock fill. Rock riprap covers the upstream face of the dam. (Courtesy Bernita Tickner.)

Cheryl Wainwright finishes gluing "hair" on the town's Big Foot statue before the October 2005 Bigfoot Days parade in Happy Camp, California. Many locals share tales about Bigfoot sightings and visitors are always hoping to catch a glimpse of the "big guy." (Courtesy Rosie Bley.)

In Happy Camp, Hazel Davis Gendron gathers up her grandchildren to take part in the 2004 Bigfoot Days Parade as the "Old Woman in the Shoe." The annual parade and festival is a celebration for locals and a major tourist attraction. (Courtesy Hazel Davis Gendron.)

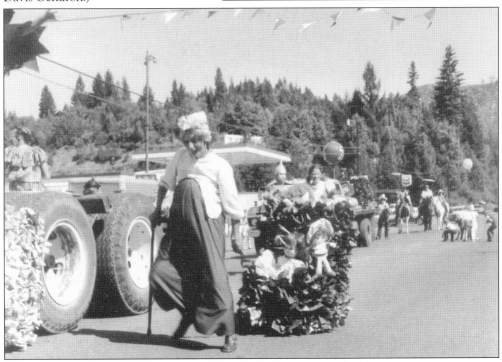

In July 1988, the First-Salmon ceremony takes place on the site of early tribal dwellings in downtown Bandon, Oregon. Among the participants are several people who were active in getting Congress to restore official recognition to the Coquille tribe. The participants, from left to right, are Sidney Richards, Chief Tony Tanner, Sharon Parrish, Jimmy Metcalf, Annabelle Dement, George Wasson, Michele Burnette, and Wilfred Wasson. (Courtesy Roberta and Don Alan Hall.)

In September 1990, archaeological work in Bandon uncovered one of the largest prehistoric village sites on the Oregon coast, as well as the site of Old Town, twice destroyed by fire. Directed by Roberta Hall and Oregon State University, with volunteers from Earthwatch Institute and the Coquille tribe, excavation provided artifacts related to historic Bandon and the fires. Deeper levels revealed hundreds of years of human presence, plus evidence of disastrous tsunamis. (Courtesy Roberta and Don Alan Hall.)

In the bottom of an archaeological excavation, Jerry Running Foxe, a member of the Coquille tribe whose ancestors inhabited the region surrounding the mouth of the Coquille River, carefully places soil-encrusted mammal bones into a box that is steadied by an Earthwatch Institute volunteer. (Courtesy Roberta and Don Alan Hall.)

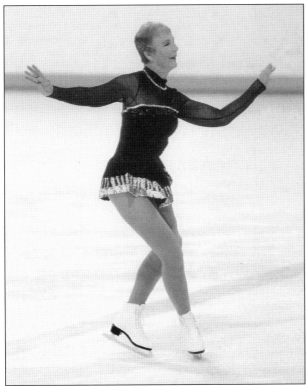

Molly MacGowan of Etna, California, just keeps winning after rediscovering her love and talent for ice-skating. She won first place at the 2005 International Adult Figure Skating Championship in Oberstdorf, Germany. A week earlier, she picked up a first place in France. In order to practice, Molly travels to Ashland and Medford, Oregon, almost daily, a round-trip of nearly 150 miles. (Courtesy Daniel Webster and the *Pioneer Press*.)

Naomi Lang, of Karuk descent, was born in Eureka, California. She began her training at age three with the Redwood Concert Ballet in Eureka. When she moved to Michigan at age eight, she began group lessons in ice dancing. Partnered with Peter Tchernyshev, the couple won the U.S. ice-dancing championship five times and placed 11th in the 2002 winter Olympic games. (Courtesy Daniel Webster and the *Pioneer Press*.)

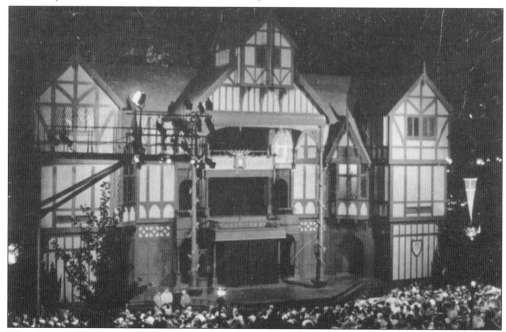

The first performances of what would become Ashland, Oregon's world-famous Shakespeare Festival began in 1935, when Angus L. Bowmer arranged an event for the city's Fourth of July celebration. Today the festival runs most of the year and plays can be seen in one of three theaters, including an outdoor theater that recreates London's Globe Theater. (Courtesy Gail Jenner.)

Celebrations and parades are important events throughout the State of Jefferson. Balloon fairs have become annual events, especially in Siskiyou County, where the contest is often held in Montague or sometimes Scott Valley, California. Each year, the number of participants grows. Occasionally, however, the balloons send cows running. (Courtesy Bernita Tickner.)

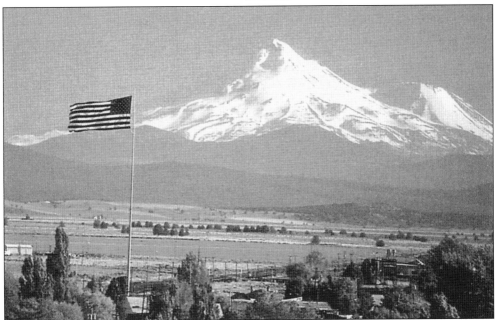

The tallest flagpole in the United States is located in Dorris, California, which is just over the California border from Oregon. The building project was organized by the Dorris Lion's Club, and the pole measures 36" wide at its base, 5.6 inches at the top and is buried in 22 feet of concrete. The American flag that flies from this towering pole measures 30 feet by 60 feet. (Courtesy Bernita Tickner.)

Ten miles south of Ashland, Oregon, stands the historic restaurant Callahan's Siskiyou Lodge (established in 1947). In order to purchase the land, Don Callahan sold a small herd of sheep after returning home from World War II. He then enlisted the help of "friends, a pick, and shovel." Today the restaurant and lodge serves skiers, hikers, and travelers as well as locals. Not far from the restaurant, motorists can catch a glimpse of Emigrant Lake in the valley below. (Courtesy Gail Jenner.)

The annual Dunsmuir Railroad Days Celebration is highlighted by a parade through historic downtown. Originally named Pusher because trains had to be pushed up the steep canyon rails that follow the upper Sacramento River, Dunsmuir's roots go back to the late 1880s and the first railroads. Railroad Days is marked by a parade, music, vendors, and activities, and the celebration attracts hundreds of tourists. Dunsmuir also sponsors a Halloween Carnival and a River Clean Up each fall. (Courtesy Nolan Printing.)

The Weed Carnivale is an annual event, sponsored by the Grand Lodge of the Order of Sons of Italy. Grand lodges were established all over the region—Cuori Uniti No. 1269 in Weed on January 6, 1924; Nobile Pensiero No. 1275 in McCloud on March 3, 1924; Eureka No. 1274 on March 16, 1924; and Camelia-Colombo Lodge No. 1294 in Klamath Falls, Oregon, in June 1924. In Weed, the carnival features a parade, dancing, music, and great food. (Courtesy Nolan Printing.)

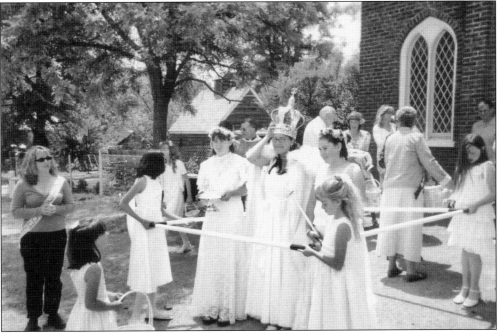

The Portuguese Holy Ghost Festival and Parade is held every year in Hawkinsville, two miles north of Yreka. Hawkinsville was settled in 1851, shortly after Yreka's first gold strike. The festival occurs each June and celebrates a time in Portuguese history when Queen Isabel, overcome by her subjects' hunger, took bread out and served it to the people. The 2005 pageant featured Laura Hall as queen and Nicole and Kari Luiz as attendants. (Courtesy Monica and Roy Hall Jr.)

In a parade through Callahan, California, during Callahan's Golden Jubilee, Ellen Hayden, whose own roots go back to the early days of settlement, drives her horse-drawn buggy. For many years, the Golden Jubilee was an annual event celebrating the gold rush history of the region. Visitors panned for gold, watched cancan girls, and danced to good ol' country music (Courtesy Gail Jenner.)

The Living Memorial Sculpture Garden, located 13 miles northeast of Weed along Highway 97, was created by Vietnam veteran and artist, Dennis Smith. Dedicated as a war memorial, the enormous metal sculptures rise up out of the surrounding brush in dramatic fashion. The sculptures are arranged in small groupings. This particular form is titled *The Flute Player*. (Courtesy Kyle Peterson.)

This sculpture appears as part of the Korean War Memorial. All of the sculptures are within walking distance of each other as Mount Shasta forms the backdrop. A recent addition to the garden is the Living Memorial Labyrinth, with five pathways designed to follow the pattern of the sacred labyrinth at Chartres Cathedral in France. (Courtesy Kyle Peterson.)

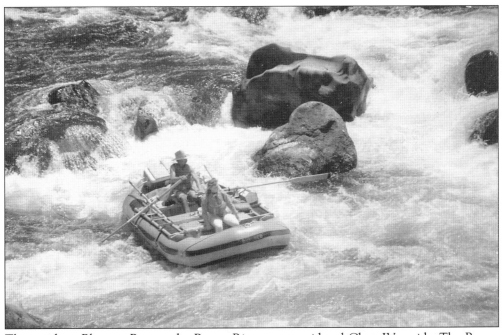

The rapids at Blossom Bar on the Rogue River are considered Class IV rapids. The Rogue River, the first nationally designated Scenic and Wild River, wends its way through narrow and deeply carved canyons. Seen here is William More and his daughter, April, shoot the rapids. (Courtesy Noah Adventures.)

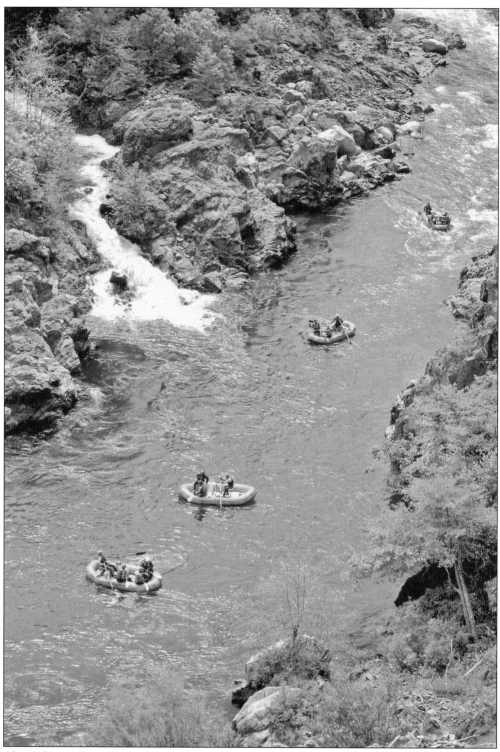

The Salmon River is also a rafter's paradise, evidenced by this summer 2004 photograph. (Courtesy Noah Adventures.)

In the fall of 2001, Erin Fowle of Etna, California, is seen plowing for Scott and Michelle Murphy on their ranch outside Etna. The horse team, Bruce and Bill, are Percheron geldings. Raising, training, and working draft horses is a pastime that has been revived in parts of Jefferson. (Courtesy Erin and Jeff Fowle.)

Four generations of Martins work cattle on the family ranch near Montague, California. Brice Martin's pioneer ancestor, R. M. Martin, brought his young bride from Tennessee to the small cabin located at the base of Table Rock, California, *c.* 1855. She is considered to have been the first white woman in Little Shasta. In 1869, R. M. was elected to the California State Legislature but died before serving his term. (Courtesy Pat Martin.)

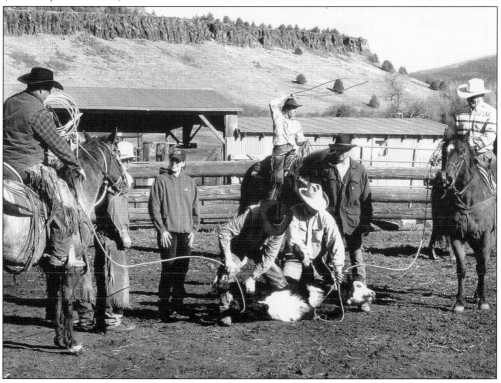

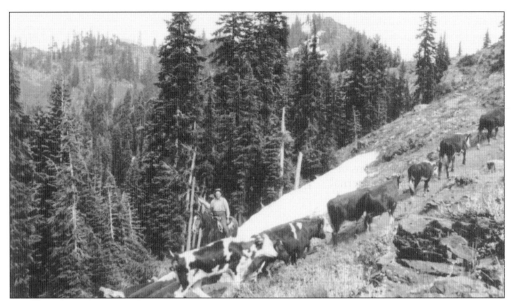

Ranging cattle in the mountains during summer has long been a tradition of ranchers in California and Oregon. Here J. Davidson counts his cattle before moving them up the trail to Big Elk Lake in the Klamath National Forest. Today fewer cattle are permitted to graze in the mountains, although ranchers contend that cattle are a natural fire retardant and when well managed, affect the environment positively. (Courtesy Nolan Printing.)

Blair Smith, another rancher from Little Shasta (near Montague, California), was California Livestock Man of the Year and is seen here herding cattle. The State of Jefferson, known for its hardy and productive cattle herds, has more and more ranchers raising grass-fed natural beef for the market. (Courtesy Nolan Printing.)

Rodeo is a family affair and a popular sport throughout Northern California and Southern Oregon. Roy Johnson of Etna, California, placed first at the 2005 High School Rodeo Finals in California, then went on to compete internationally. Out of more than 150 contestants, the 16 year old came in 18th place. Roy comes from three generations of rodeo riders on both his maternal and paternal sides. (Courtesy Liz Bowen.)

Roy Hall Jr. is riding Kiaik and leading Kamisha (meaning dream and day in the Shasta language) on a three-day trip from Lover's Camp on the Scott River, through Marble Valley to Wooley Creek on the Salmon River. Roy is the chairman of Shasta Tribe, Incorporated/Shasta Nation. A retired timber feller, Roy works for Heal Therapy as a Registered Therapeutic Equestrian Instructor. Roy and Kamisha are completing their Level 2 in Parelli Natural Horsemanship. (Courtesy Candy Cook-Slette.)

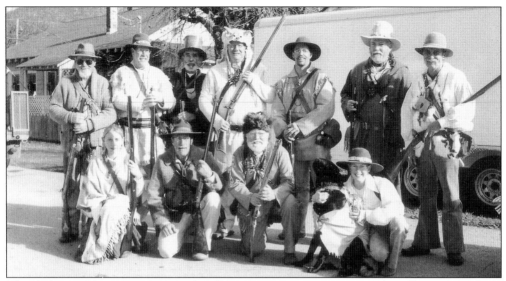

The Siskiyou Mountain Men, avid Jefferson staters, appear in parades all over Northern California. Another group, Little Butte, travels all over Southern Oregon. Here the Siskiyou Mountain Men have gathered for the Fort Jones Christmas Parade in 2001. Four of the members are Bobby Williams, "Pilgrim" Don Sargeant, Ted Sewell, and Jack "Snuffy" Berggreen. Each carries a black powder rifle and the outfits are hand sewn or made to recreate authentic mountain man attire. (Courtesy Liz Bowen.)

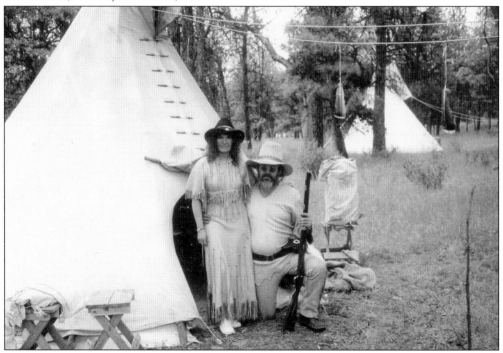

This mountain man rendezvous (or "Rondyvoo") was held at Pit River, east of Burney. The Siskiyou Mountain Men sponsor three such rendezvous a year, the largest one at Grass Lake in July. They hold challenge shoots against Little Butte (the name of the Oregon group), and 400 to 500 people attend each rendezvous. (Courtesy Jack Berggreen.)

Four

THE 49TH STATE
OF THE UNION

You are now entering Jefferson, the 49th State of the Union. Jefferson is now in patriotic rebellion against the State of California and Oregon. The State has seceded from California and Oregon this Thursday, November 27, 1941. Patriotic Jeffersonians intend to secede each Thursday until further notice.

—State of Jefferson Citizens Committee (1941)

The State of Jefferson cannot be found on any map of the United States, but the struggle to establish a separate state (by any number of names) has gone on for 150 years, since the days of the California and Oregon gold rush. It was identified by Judge John L. Childs, who stated in his formal "inaugural" address as "governor" of the emerging state on December 4, 1941: "The State of Jefferson is a natural division geographically, topographically, and emotionally. In many ways, a world unto itself: self-sufficient with enough water, fish, wildlife, farm, orchard land, mineral resources, and gumption to exist on its own." Today most Jefferson staters continue to seek recognition, if not in political terms, certainly in cultural terms, while others dream of splitting California into two or three states. Some claim there is significant reason to do so, and point to the dramatically and distinctly different geographies, economies, and attitudes that characterize the people of Northern California and Southern Oregon.

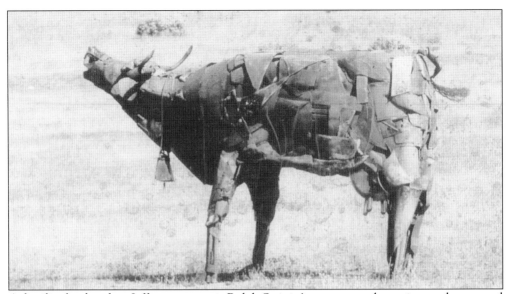

A familiar landmark to Jefferson staters is Ralph Starritt's monumental creation—a huge metal cow sculpture. Made from scrap metal and poised on a hillside south of Yreka, California, a short distance from a large hay barn with "State of Jefferson" painted in bold letters, motorists and locals enjoy seeing what holiday or seasonal costumes the old cow dons. (Courtesy Ralph Starritt.)

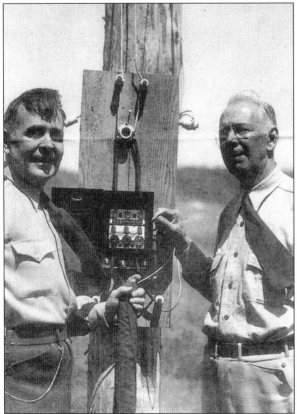

Gilbert Gable, mayor of Port Orford, Oregon, was one of a group of men who stormed into the Curry County courthouse, demanding that the county be transferred from Oregon to California. Perhaps to appease the crowd, the judge appointed a group to study such a move. This act was one of the triggers leading to the 1941 "rebellion." In 1935, Gilbert, left, stands with Van DeGrift in Port Orford. (Courtesy Port Orford Library.)

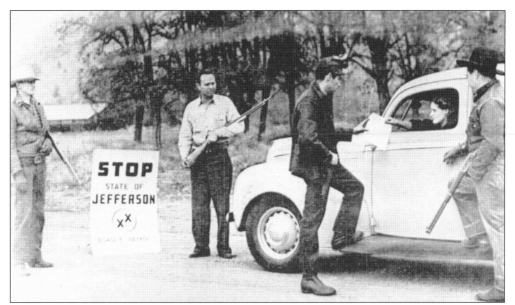

This traffic-stopping patrol is really State of Jefferson protestors who, on November 27, 1941, set up a roadblock along old Highway 99, south of Yreka, California. William "Bill" Maginnis is pictured here, approaching an unidentified motorist, to read the Proclamation of Independence crafted by members of the Yreka 20-30 Club. The protestors, from left to right, are Frank Russey, unidentified, William "Bill" Maginnis, and Raleigh Stevens. (Courtesy Siskiyou County Museum.)

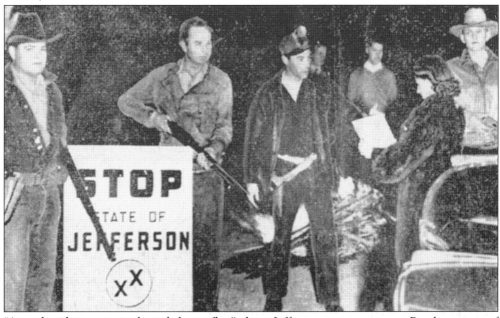

"Armed with target pistols and deer rifles," these Jefferson staters pass out Proclamations of Independence and windshield stickers that stated, "I have visited JEFFERSON, the 49th state." A closer view of the State of Jefferson protestors standing near their road sign on Highway 99 includes, from left to right, Raleigh Stevens, unidentified, William "Bill" Maginnis, and Frank Russey. (Courtesy Siskiyou County Museum.)

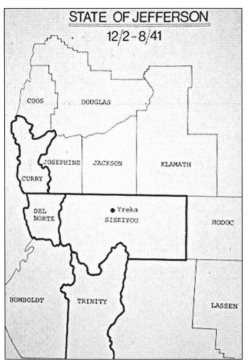

STATE OF JEFFERSON
12/2-8/41

COOS · DOUGLAS

JOSEPHINE JACKSON KLAMATH
CURRY

DEL
NORTE · Yreka
SISKIYOU MODOC

HUMBOLDT TRINITY LASSEN

The map of the proposed State of Jefferson has changed many times over the years. In the 1850s, it included only those counties bordering Oregon and California where miners hoped to avoid paying taxes by declaring themselves residents of one or the other state. Over time, other counties have joined in the protest, especially in relation to issues involving natural resources, highways, and roads. (Courtesy Rosie Bley.)

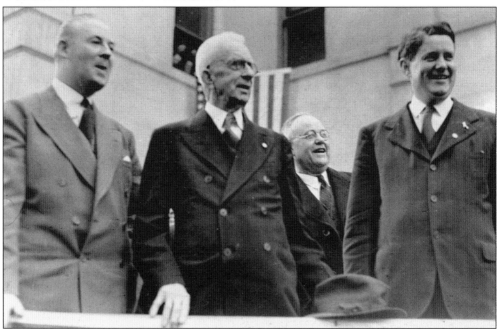

On December 4, 1941, standing at the podium on inauguration day are Gordon Jacobs, supervisor from Hornbrook; Judge John C. Childs, the new governor; and Sen. Randolph Collier, one of Siskiyou County's own native sons. Collier was a powerful California senator, sometimes called "The Gray Fox." He was also given the title "Father of Highways" for his efforts to develop Interstate 5 and other highways and roads throughout the region. (Courtesy Siskiyou County Museum.)

Posed outside the assay office in Yreka, California, the new state's politicians debate one of the hottest issues of the day—the concern over mining copper ore. Convinced that the region had been overlooked for too long, these men proposed that the new state utilize its resources in order to generate revenue. Pictured, from left to right, are (first row) George Milne, Randolph Collier, and Bill Lange; (second row) Joe Correia (unconfirmed), J. P. Maginnis, and Homer Burton. (Courtesy Siskiyou County Museum.)

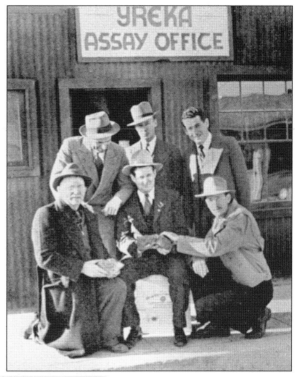

Yreka's George Wacker, a successful businessman and local historian, was involved in the State of Jefferson movement. Here he stands with Sen. Randolph Collier and an agency representative from Sacramento. In addition to supporting the State of Jefferson movement, Collier worked to bring money to the region, especially in relation to highways and roads. He came to be known as "The Father of Highways," and construction of Interstate 5 and many of the smaller highways were overseen by Collier. (Courtesy Frances Wacker.)

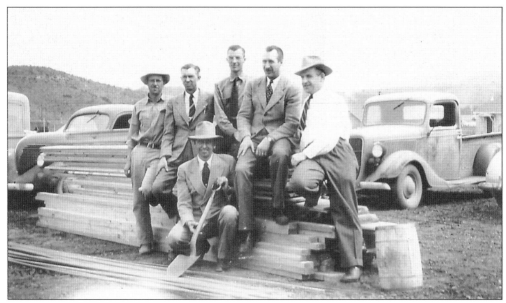

In the 1940s, the board of directors and employees of the local radio station pose for a photograph as supporters of the State of Jefferson movement. Note the shovel; it became a symbol of what was needed to break through the hard rock for mining and for road repairs. Pictured, from left to right, are (first row) Jim Holfinger; (second row) unidentified, unidentified, Milt Peterson, George Wacker, and Fred Burton. (Courtesy Beth Marie Butler and Betty Holland.)

Throughout the 1950s and early 1960s, Richard J. Dolwig, a Republican assemblyman from San Mateo County, California, was a strong proponent for dividing California into two or three separate states. When interviewed, he repeatedly stated that the needs and interests of the north and south were so diverse that the two regions would never resolve their differences satisfactorily. (Courtesy Tamar Dolwig.)

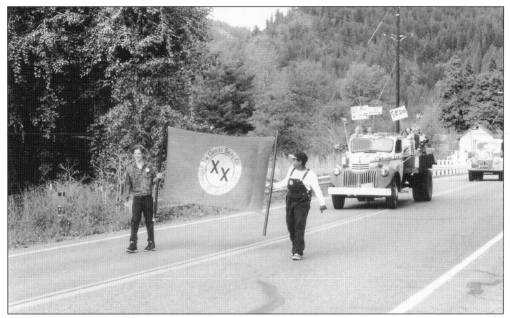

In October 1998, a State of Jefferson "reenactment" was staged, recreating the events of November-December 1941. Protestors carry the official green flag, emblazoned with the familiar gold pan with two Xs (symbolic for double cross). Along the highway, observers cheered. (Courtesy Liz Bowen.)

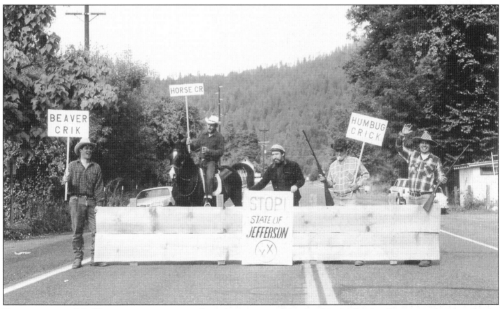

Protestors and Jefferson staters carry their banner and signs down the highway as they recreate the State of Jefferson revolt that surfaced in 1941. That protest was quickly tabled when Pearl Harbor was attacked on December 7, but its ideals continue to influence the region. One of the participants included Brian Petersen, a local State of Jefferson advocate. (Courtesy Liz Bowen.)

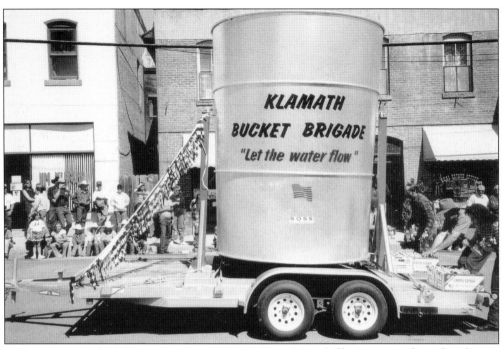

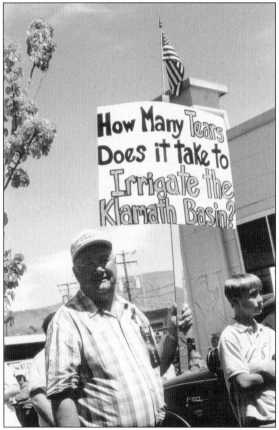

Many Jefferson staters showed up for the 2001 Klamath Bucket Brigade and protest staged in Klamath Falls, Oregon, after the region's farmers had their irrigation water cut off in a battle over whose water rights prevail, the fish's or the farmer's. The parade wound through downtown Klamath Falls, with thousands in attendance. Seen here is the Klamath Bucket Brigade participating in the Scott Valley Pleasure Park rodeo parade in Etna, California. (Courtesy Liz Bowen.)

John Crawford, a Tulelake farmer, holds up a sign to protest the court's ruling to shut off water designated for agriculture. Along with hundreds of others marching down the main streets of Klamath Falls, he staunchly opposed the perceived attack on property rights. Those in the State of Jefferson continue to view their region as misunderstood and mistreated by state and federal governments. (Courtesy Liz Bowen.)

In May 2003, the water was turned on after Klamath farmers' water rights were reinstated, but many farmers had to sell out before the water was returned. Local economies suffered during the two years that farmers waited to be heard. Officials in attendance included Ann Veneman, U.S. secretary of agriculture; Gale Norton, U.S. secretary of the interior; and Oregon senator Gordon Smith. (Courtesy Liz Bowen.)

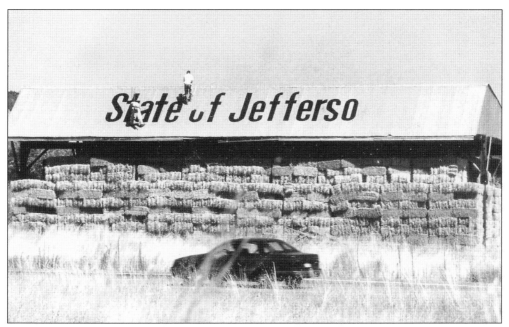

In 1997, Brian Helsaple (now deceased) and his nephew, both staunch Jefferson staters, paint "State of Jefferson" in enormous letters across a large hay barn south of Yreka, California. The sign, easily spotted by motorists on Interstate 5, is the subject of frequent questions by tourists passing through the region. (Courtesy Liz Bowen.)

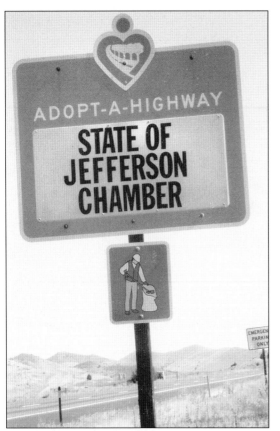

A State of Jefferson Chamber of Commerce was established, and throughout the region there are signs supporting its existence. Here is a road maintenance sign. The official Jefferson headquarters is now located at the *Pioneer Press* office. The *Pioneer Press* is a regional, independent newspaper published in Fort Jones, California. There is also an active State of Jefferson website. (Courtesy Gail Jenner.)

The State of Jefferson National Scenic Byway was officially established in 1993 and criss-crosses the entire region. By following the signs, visitors can easily document the terrain and unique geography that constitute the area. This effort is, for many, a way to promote both the region's natural wonders as well as maintain its ruggedly individualistic ideals. (Courtesy Gail Jenner.)

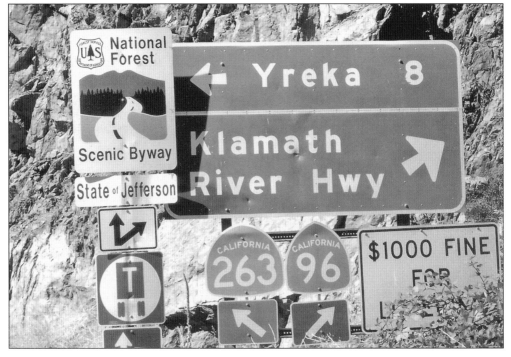

In the 1990s, the Yreka Jefferson Community Band was created by Fred Wichman. Today the official State of Jefferson Band plays at parades and festivities all over the area. Here they are playing at a State of Jefferson fair in Etna. A few of the participants include Tom Jopson, Sophie McBroom, and Tamra and Harriett Rivallier. (Courtesy Liz Bowen.)

Another important local enterprise is Jefferson Public Radio, located at Southern Oregon University in Ashland, Oregon. Originally designated KSOR, the small 10-watt, student-run station has become a regional public radio service reaching over one million potential listeners in a 60,000-square-mile area of Southern Oregon and Northern California, roughly the area of the State of Jefferson. Thus, in 1989, the call letters became JPR. Behind the control panel sits Eric Teel, one of JPR's deejays and hosts. (Courtesy Gail Jenner.)

One of the outgrowths of the State of Jefferson movement was the establishment of a chapter of People for the U.S.A. According to Ric Costales, one of its founders, the goal of the chapter is to protect individual freedoms and to bring to light matters facing people locally that, in fact, have little coverage but tremendous national impact. Here three members attend a board of directors' meeting in Sacramento, California. Pictured, from left to right, are Ric Costales, Brian Petersen, and Tebeau Piquet. (Courtesy Liz Bowen.)

Terry Bowen, at right, an avid Jefferson stater, presents California congressman Wally Herger a Siskiyou County T-shirt at a town hall meeting in Yreka, c. 2001. Herger has been an active supporter of the SOSS (Save Our Shasta and Scott Valleys and Towns) campaign promoting rural values and issues. Even after 150 years, those in the State of Jefferson are still voicing concerns that are unique to this region. (Courtesy Liz Brown.)